On the
Edge

On the Edge

Contemporary Art from the
Werner and Elaine Dannheisser Collection

Robert Storr

With an introduction by

Kirk Varnedoe

The Museum of Modern Art, New York

Distributed by

Harry N. Abrams, Inc., New York

Published on the occasion of the exhibition *On the Edge: Contemporary Art from the Werner and Elaine Dannheisser Collection*, at The Museum of Modern Art, New York, September 30, 1997–January 20, 1998. Organized by Robert Storr, Curator, Department of Painting and Sculpture

This publication is made possible by a generous grant from Agnes Gund and Daniel Shapiro

Produced by the Department of Publications
The Museum of Modern Art, New York
Edited by David Frankel
Designed by Bethany Johns Design, New York
Production by Marc Sapir
Printed and bound by Stamperia Valdonega, Verona, Italy

Library of Congress Catalogue Card Number: 97-072613
ISBN 0-87070-054-5 (MoMA)
ISBN 0-8109-6178-4 (Abrams)

Published by The Museum of Modern Art
11 West 53 Street, New York, New York 10019

Distributed in the United States and Canada by Harry N. Abrams, Inc., New York

Back cover: Felix Gonzalez-Torres. *"Untitled" (Portrait of Elaine Dannheisser)*. 1993. Paint on wall, dimensions variable. Here designed as a book cover, in the typeface and color specified by the artist. Fractional gift of Werner and Elaine Dannheisser. See p. 63

Printed in Italy

Contents

Foreword

The Collection of The Museum of Modern Art is, historically, the aggregate of many collections once belonging to individuals, steadily augmented by acquisitions made through the Museum's various curatorial departments. The foundation stones upon which this now vast and detailed imaginative edifice stands were laid by a generation of patrons, most of whom have already passed from the scene. The precedent-setting donation of this kind came in 1931, as the bequest of Lillie P. Bliss, one of the Museum's three founders, and it comprised thirty-three oils; thirty-three watercolors, drawings, and pastels; and fifty prints. All were offered in the still more generous understanding that the works included could, after careful consideration by the staff, be traded for other items deemed more necessary to the Museum's overall scope, a decision that has resulted in Miss Bliss's name appearing on numerous important works brought into the collection after her death. To honor her initial donation and the beginnings of the ambitious acquisitions program it inaugurated, a complete catalogue was published.

Over the years, gifts from many sources have complemented this first gesture. The works thus added to the Museum's holdings describe modern art's evolution and variety with ever greater range and vividness, and the names attached to each of these contributions have become a part of the history not only of this institution but of taste more generally as well. Chief among them are the collections presented to the Museum by the members of the Rockefeller family, beginning with Abby Aldrich Rockefeller (who, along with Miss Bliss and Mary Quinn Sullivan, was one of the Museum's three original sponsors) and continuing through the gifts of Nelson Rockefeller, Blanchette Rockefeller, and David Rockefeller, all three of whom served as chairman of the Museum's board. Recently the Museum has also celebrated the major contributions made by William Paley, Louise Smith, Florene M. Schoenborn and Samuel A. Marx, and Philip Johnson. The Werner and Elaine Dannheisser Collection adds to these illustrious gifts and dramatically expands the range of the Museum's collection.

With the exception of the Dannheisser Collection, most of these gifts have tended to focus on modernism's formative stages. As we approach the century's end, however, it becomes more than ever clear that modern art, which began in the last century, is on the verge of spilling over into yet a third.

Thus the past, as seen through works given by the patrons just mentioned as well as by many others, is prologue to artistic events that are just starting to make themselves known. The very rationale for assembling and maintaining such rich reserves is mandated by the continuity of modern art's growth and diversification. Comprehensive collections of this kind — and it is not boasting to say that the Museum's has no equal — serve art both old and new, that which has at last been accepted and that still hotly argued over, by offering revealing perspectives forward and backward in time. In this manner we may trace the origins of the latest novelty and discover levels of meaning not immediately apparent to still unaccustomed eyes, or we may reconsider works familiar to us in the light cast by the best of the most recent and so far unfamiliar things.

Accordingly, our experience of classic German Expressionism and American Abstract Expressionism may be refreshed by looking at the work of painters such as Anselm Kiefer or Sigmar Polke, even as our appreciation of these contemporary painters is deepened by awareness of what preceded them. A similar relationship exists between earlier abstraction of the Dutch, Russian, French, and American schools, regularly on display in the Museum's second- and third-floor galleries, and the austere painting and sculpture of Carl Andre, Richard Long, Brice Marden, Robert Ryman, and Richard Serra. In the photographic tradition, the links from pioneers like Eugène Atget, August Sander, and Walker Evans to living artists such as Bernd and Hilla Becher, Dan Graham, Andreas Gursky, and Thomas Struth are equally plain. Similarly fruitful comparisons can be made between the conceptual objects, paintings, text pieces, photographs, and installation practices of pre- and post-World War I Dadaists such as Marcel Duchamp and Francis Picabia (whose graphic ideas also have bearing on Polke) and the multifarious output of Matthew Barney, Joseph Beuys, Katharina Fritsch, On Kawara, Jeff Koons, Bruce Nauman, Cindy Sherman, Lawrence Weiner, and Christopher Wool.

From Andre through Wool, the contemporaries cited above constitute just a partial list of those included in the Werner and Elaine Dannheisser Collection as it becomes an integral and permanent part of the Museum's own. By her own account, Elaine Dannheisser began acquiring work as

many people do — by looking for prime examples of already recognized masters. First educating herself in New York's museums, she then traveled abroad, searching out modern art's roots. "In Europe I got very involved with art history," she recently recalled, "especially the whole era of the '20s with Gertrude Stein and Picasso. I used to say to myself, 'Oh would I have loved to have lived then.' Then I realized that art is happening now: art history is always being made." She was right, and more than that she was determined to live the present as fully and as critically as possible.

Pursuing and securing individual works, studying them in different combinations, winnowing some out and selectively supplementing those she retained while branching out in unanticipated directions, Mrs. Dannheisser, collecting on behalf of herself and her late husband, charted an independent path through the maze of new ideas and styles that characterized the '70s, '80s, and '90s. The result is an ensemble unique in its breadth, depth, and consistent edginess. A shrewd judge of which of the artists momentarily rising in the ranks of the avant-garde had the greatest staying power, Mrs. Dannheisser was quick to acknowledge that what they produced was frequently perplexing and provocative. Where the aggressive imagery or austere means used by so many of them might have put some collectors off, or at least prompted them to pick less difficult or upsetting examples, Mrs. Dannheisser met these challenges on the artists' terms and consistently embraced the toughest work they made. Consequently, the things she immediately gravitated toward and held on to longest tended to run hot or cold, but never lukewarm.

In all, thirty-three artists from Europe and America are represented here by eighty-five paintings, sculptures, drawings, videos, neons, photographs, photomontages, texts, billboards, and installations. In several cases, these pieces are the first by the artist to enter the Museum's collection; in other instances this gift dramatically enhances the Museum's ability to document the careers of artists whose presence had previously been confined to one or two works. Considered altogether, the Dannheisser Collection is the largest single gift of contemporary art yet given to the Museum at one time. The net effect of the Dannheissers' daring and open-handedness is to fast-forward the Museum's running account of modern art in a spirit wholly in keeping with the audacious efforts made by the benefactors who established the Museum and gradually ensured its status as the modernist collection of record. The Dannheisser donation thereby meets the highest standards and simultaneously reconfigures them in the image of contemporary art.

Gratitude for this boon is due first and last to Elaine Dannheisser, who shaped its contents in every way, and to the memory of her husband, Werner. Next, within the Museum community, warmest thanks go to the Museum's President, Agnes Gund, for her steadfast commitment to making this hoped-for result a reality, and who, with Daniel Shapiro, also made the present publication possible. A great debt is also owed to Beverly M. Wolff, the Museum's Secretary and General Counsel. Finally, this publication and the exhibition that it accompanies would not have been possible without the extraordinary efforts of Robert Storr, Curator in the Department of Painting and Sculpture. A devoted friend of Elaine Dannheisser's, and a passionate advocate of the work of the artists she collected, Mr. Storr was instrumental in securing for the Museum the collection she formed. Few scholars are more sensitive to the work of contemporary artists than Mr. Storr, and his insights enliven the catalogue and help place the work of the artists in the Dannheisser Collection in the broader context of the history of modern art.

The exhibition commemorated by this catalogue marks a signal occasion, and the work in it fleshes out a picture of a fertile, widely misunderstood, and still unfolding time. For those tempted by the thesis that modern art has run its course, here is proof positive that such predictions are short-sighted and that contemporary art, which is nothing less than the modern art of our day, is as good as ever, and as inviting to debate. This Museum has always welcomed that debate in the belief that there is no better place for it to occur than in the presence of the works that inspired it. With an energizing jolt, the Werner and Elaine Dannheisser Collection brings that process up-to-date and confirms this institution's determination to remain at its center.

Glenn D. Lowry
Director, The Museum of Modern Art

Acknowledgments

A project of this kind is the work of many hands. The order in which they will be thanked reflects The Museum of Modern Art's many layers rather than the degree of effort expended by individuals, since full participation by all concerned in every one of this institution's departments was necessary for the realization of this exhibition and its accompanying catalogue.

First, then, appreciation goes to the staff of the Department of Painting and Sculpture who coordinated this endeavor museumwide: to the Chief Curator, Kirk Varnedoe, who worked hard to bring this event about, and who has contributed the catalogue's introduction; to Carolyn Lanchner and Kynaston McShine, respectively Curator and Senior Curator in the Department, whose expertise was essential to the final selection; to Carina Evangelista, my assistant, who ably and amiably met the trial by fire that this project was; to the unfazable Elizabeth Levine, Curatorial Assistant, for her central role in supervising the preparation of both the exhibition and the catalogue; to Anne Umland, Assistant Curator, for her involvement in that same process, as well as to Stacy Glass Goldstone, Administrative Assistant, for the same; and to Victoria Garvin, Administrator/Assistant to the Chief Curator, for managing the many formal details of this acquisition.

Among members of the other curatorial departments that are beneficiaries of this gift, thanks are owed to Peter Galassi, Chief Curator of Photography, along with Susan Kismaric, Curator, and M. Darsie Alexander, Curatorial Assistant in that department; Margit Rowell, Chief Curator of Drawings, and Kathleen Curry, Curatorial Assistant; Deborah Wye, Chief Curator of Prints and Illustrated Books, and Starr Figura, Assistant Curator; and Barbara London, Associate Curator in the Department of Film and Video. From this last department, Charles Kalinowski, Head Projectionist, and Anthony Tavolacci and Gregory Singer, Projectionists, also provided necessary assistance.

Among the editorial staff, gratitude is due Harriet Bee, Managing Editor; David Frankel, Editor, of the perfect bedside manner for stressed wordsmiths; Marc Sapir, Production Manager; Nancy Kranz, Manager of Promotion and Special Services; and Heather DeRonck, Senior Production Assistant. Credit for catalogue design belongs to Bethany Johns, a free-lance designer, and Jean Garrett, who

assisted her, as well as to Jody Hanson, Director of the Department of Graphics, and her staff. Kate Keller, Chief Fine Arts Photographer, and Erik Landsberg, Fine Arts Photographer, took many of the photographs for the catalogue, with the contribution of independent photographers David Allison and also Bill Orcutt. Mikki Carpenter, Director of the Department of Photographic Services and Permissions, aided by Jeffrey Ryan, Senior Assistant, Photographic Archives, were also actively engaged in securing images for reproduction.

Exhibition planning at all levels has involved Jennifer Russell, Deputy Director for Exhibitions and Collections Support, as well as Linda Thomas, Coordinator of Exhibitions, Eleni Cocordas, Associate Coordinator, and Rosette Bakish, Secretary, all from the Exhibition Program. We have also called on the skills of Diane Farynyk, Registrar; Ramona Bronkar Bannayan, Associate Registrar; Cheryl Horwitt, Registrar Assistant; Pete Omlor, Manager, Art Handling and Preparation, and his staff of preparators; and from the Department of Exhibition Design and Production, Jerome Neuner, Director, Karen Meyerhoff, Assistant Director, and Mark Steigelman, Exhibition Supervisor. Conservation of the works was attended to by Anny Aviram and Karl Buchberg, Conservators, and Patricia Houlihan and Lynda Zycherman, Associate Conservators.

The Department of Education has been represented in this project by Patterson Sims, Deputy Director for Education and Research Support, and Josiana Bianchi, Public Programs Coordinator. The Department of Communications has contributed through the efforts of Alexandra Partow, Assistant Director, Mary Lou Strahlendorff, Press Representative/Electronic Media Coordinator, Lisbeth Mark, Press Representative, and Tavia Fortt, Writer/Editor.

Beverly M. Wolff, Secretary and General Counsel to the Museum, was instrumental in all legal aspects of securing this donation, and she was ably assisted by Stephen W. Clark, Assistant General Counsel, and Kristin Whiting, Paralegal. Michael Margitich, Deputy Director for Development, played an equally essential role.

I want to extend my warmest appreciation to Agnes Gund, President of The Museum of Modern Art, for her indispensable part in welcoming Elaine Dannheisser into the Museum community. Furthermore, it is through the generosity of Ms. Gund and her husband Daniel Shapiro that this catalogue documenting the Dannheisser Collection has been made possible.

Finally, I wish to thank Elaine Dannheisser for her patience and care in helping us to prepare this exhibition and catalogue. Her assistance in identifying and assessing works and in verifying facts was invaluable, as was that of the artist Jim Hodges, her preparator and conservator during recent years. Elaine Dannheisser's donation marks a turning point for the Museum in its relation to international contemporary art; working on it with her has been a personal pleasure.

Robert Storr

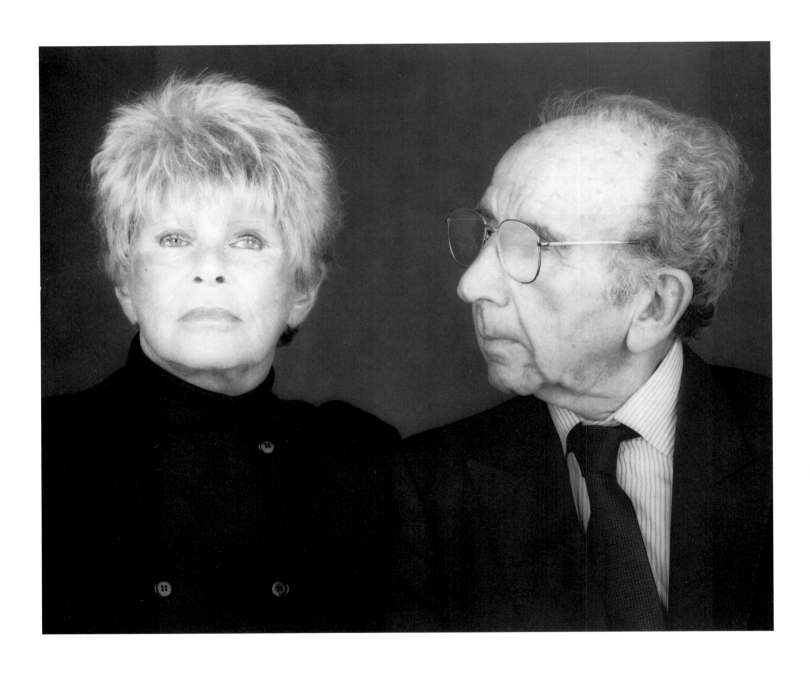

Introduction

Kirk Varnedoe

In celebrating a collection, we also honor a collector, and a very special history of decisions and commitments. Ours is the fortunate opportunity of surveying, with the cool eye of curatorial retrospect, the works that Elaine Dannheisser has donated to this Museum; now that the collection has taken on its definitive character, we can somewhat clinically analyze the areas of depth, highlight the key pieces, and survey the breadth of coverage. It was quite another thing, though, to form that array item by item, to strategize the hunt, make sober choices while in the intoxication of pursuit, know when to commit and when not, what and when to buy or sell. Collecting art is at any moment an enterprise that exerts sharp, panic-quick pressures not only on one's purse but on one's taste and judgment, exercising and testing the gambler in one's makeup, and the related ability to discern which instincts must be followed with fearless trust and which must be stifled. Add to this the pleasures and perils of the personal relationships that inevitably obtain when the mix of collectors and dealers is joined to a community of young and ambitious artists, and the pressure-cooker atmosphere intensifies. Furthermore, in the prime moments when Elaine Dannheisser formed her collection, during the 1980s, this constant, ever present "heat" on the contemporary acquisitor's act accelerated into a collective fever in the context of a hyperexcited, acutely fast-paced and volatile art market. To have emerged from the crossfires of those years with a collection of integrity and focus, as rich in quality and as singularly, personally shaped as Mrs. Dannheisser's, is a feat that speaks volumes for her special combination of passionate engagement, hard-headed detachment, and just plain toughness.

There could never be a simple school for training such virtues in a collector, and Mrs. Dannheisser arrived at the ground of her best opportunities and challenges — the global contemporary-art market of the mid- and late 1980s — via a path marked by more than one sharp turn. Earlier in her life, in the late 1940s, she had herself been an aspiring painter, studying at the Art Students League of New York. In 1953, she married Werner Dannheisser, one of the principal partners in New Hermes, a prosperous engraving business. They traveled frequently to Europe, and as Mrs. Dannheisser saw more of the ambitious painting in the museums and galleries of the Continent, she became progressively more dissatisfied with her own work. Though she maintained a keen interest in art, she began to turn away from painting, and chose instead to study art history, at the New School, and interior design and decorating, at the New York School of Interior Design.

From the years of this study, in the 1960s and 1970s, two experiences stand out in her memory as decisive for the shaping of her engagement with modern art. One was a professor's assignment to conceive a contemporary interior and propose decoration for it, without recourse to a single antique object or accoutrement. This was the project that first forced her to concentrate on the special properties of modern, as opposed to older, design. She also recalls that an exhibition of contemporary Italian objects and furniture at The Museum of Modern Art — *Italy: The New Domestic Landscape*, in 1972 — had a decisive impact on her sensibility, convincing her of the excitement and energy in contemporary creativity. Inevitably, this new conviction came to affect Mrs. Dannheisser's sense of the art she wanted to live with at home, and affected the collecting that she and her husband pursued together.

Werner Dannheisser had already begun collecting before the marriage, with a focus on French painting of the mid-twentieth century, mostly by artists whose names are now all but forgotten. The first painting he and his new wife bought together was an Utrillo, in 1954. Throughout the later 1950s and the 1960s they continued to collect in this vein, purchasing, for example, works by Kisling and Rouault. Mrs. Dannheisser also continued to advance her education in modern art through her studies in art history at the New School, and through faithful attendance at lectures offered by the Metropolitan Museum of Art. Her horizons as a collector broadened accordingly, and the collection came to include works not only by Picasso and Dubuffet but by New York School artists such as Gottlieb.

Mrs. Dannheisser was also strongly marked by the heightened media attention that was given, in the 1960s, to collectors of modern and contemporary art. Coming across magazine articles on collectors such as Burton and Emily Tremaine, she

Werner and Elaine Dannheisser.
Photograph: Robert Mapplethorpe, 1987

27 Duane Street, New York, with works on view by
Jeff Koons (see p. 77), Thomas Struth (see p. 129),
Bruce Nauman (see p. 97), Tony Cragg (see p. 41),
and Christopher Wool (see p. 137).

would clip the photographs of the installations of art in their homes, fascinated both by their courage in embracing cutting-edge art and by their ways of showing what they owned. She constantly tested her own sense of installation against these models, and aspired to form a collection of similar force.

The first of a series of shifts aimed at furthering these ambitions came in the mid-1970s, when the Dannheissers moved to an apartment on Park Avenue. Regular attendance at auctions had kept them in touch with patterns of growth in the fast-expanding modern-art market, and Mrs. Dannheisser was particularly aware of the influx of purchasers from Japan that was then driving a rising market for modern French pictures. She persuaded Mr. Dannheisser that the time had come to sell some of their previous purchases, beginning with the Utrillo, which she was convinced would reach a handsome price. Mr. Dannheisser was more cautious and skeptical, but when the canvas did sell at the predicted level, the couple immediately converted the windfall into the purchase of a Mark di Suvero sculpture (since sold) for their terrace and a recent canvas by Willem de Kooning, *Untitled XI* (1975–76). Through the remaining years of the 1970s, prodded by Mrs. Dannheisser's growing focus on things more contemporary as well as by her sense of the opportune moment of value, the couple steadily sold off their holdings of lesser French modernists in order to fuel new purchases.

A still more decisive change took place in 1981, when Mr. Dannheisser sold his interest in New Hermes. By now a well-traveled veteran of international art fairs, Mrs. Dannheisser suddenly found herself armed with an expanded budget for collecting, at the same time that she was confronted by a rapidly changing field of contemporary art. She was determined to give a more decisive shape and character to the collection, and to become engaged with contemporary creativity in an active, participatory way. The idea then came to her of moving beyond the former notion of the art collection as part of the home environment, in the model established by the Tremaines and others. Instead she would purchase a separate space, a kind of personal museum in which her purchases could be shown in a more coherent, gallerylike presentation, in proximity to the SoHo area that was the center of New York's downtown contemporary-art milieu. One weekend just after she had conceived this project,

Thomas Messer, then the Director of the Solomon R. Guggenheim Museum, was a house guest at the Dannheissers' home in East Hampton; immediately enthusiastic, he suggested that a professional curator be hired to advise on stocking the new space, and that the museum participate in its management. Though initially excited by this offer of support, on reflection Mrs. Dannheisser made the decision — telling, and characteristic — to remain independent, and to follow through entirely on her own. After looking for almost a year and half for a suitable property (she once came close to purchasing that well-known night spot of the 1970s, the Mudd Club), in 1982 she found and acquired a ground-floor space at 173 Duane Street. Then she set out to fill it.

Mrs. Dannheisser was determined not simply to acquire contemporary art but to do so in a systematic way that would form an ensemble of depth and seriousness. In pursuit of this goal, she was convinced that she should not focus just on one artist but should cast her net widely. Sifting advice from friends and associates, she launched herself on an entirely new pattern of buying, beginning with the purchase of Richard Artschwager's *Organ of Cause and Effect* (1981) from Leo Castelli, and then proceeding through a rich vein of the most sought-after contemporary painting of the day, including works by Jean-Michel Basquiat, Kenny Scharf, Keith Haring, and David Salle. At the time, in the early 1980s, vivid and exuberant painting was fueling a burst of growth in the art market, after the dominance of comparatively austere sculpture and conceptually based art in the previous decade. For a collector fresh on the scene, regardless of seriousness of purpose, getting what one wanted in this milieu was not a straightforward or self-evident process. Mrs. Dannheisser remembers rising on one occasion at 6 A.M. to arrive at a gallery at 8:30 on what was in principle the first day of an exhibition, only to find all the works already sold. Competitive collectors, operating in a volatile world of hot rumors, supercharged egos, and heady cash flow, vied for opportunities to acquire the best of the emerging talents. Mrs. Dannheisser was in the thick of it, and passionately active.

Yet, at a critical point in the mid-1980s, she became deeply dissatisfied with the results. Walking into her Duane Street space, which was hung with an array of paintings

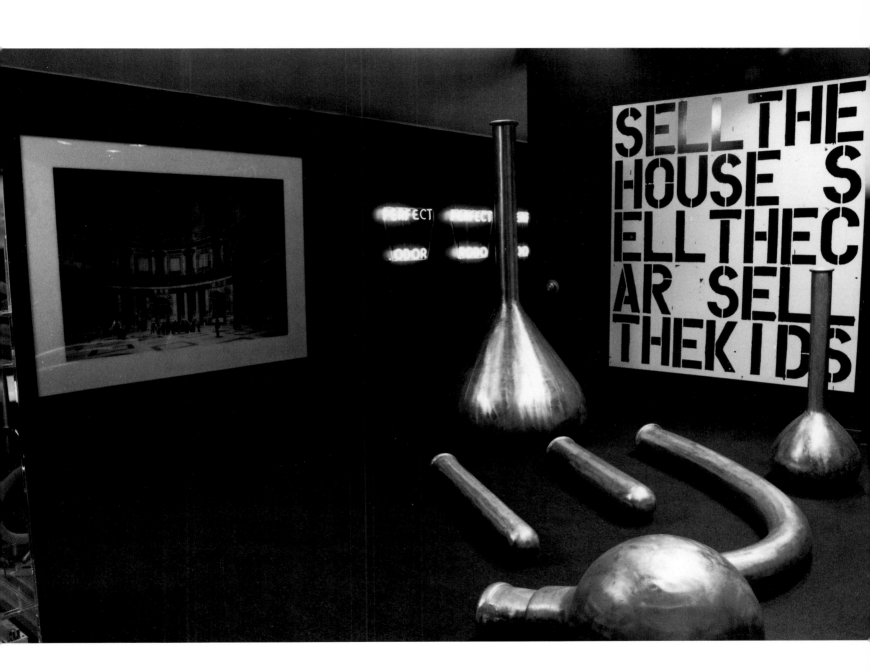

27 Duane Street, New York, with works on view by Robert Gober (see p. 49), Cindy Sherman (see p. 127), and Bruce Nauman (see p. 99).

by several of the trendiest artists of the time, she saw the ensemble as too predictable, too much in conformity with the approved taste of the moment—a downtown, ostensibly avant-garde space that was in essence indistinguishable, she says in retrospect, from "a rich woman's uptown apartment." This was not at all what she wanted, and she resolved, once again, to alter her direction—to empty out most of what she had acquired over the past four or five years, and to begin once again to form, on new, revised terms, the serious, in-depth contemporary collection that had long been her aim. Once more profiting by selling paintings at their prime moment of desirability, Mrs. Dannheisser cleared her collection of much of its early-1980s American painting and redirected her funds into different areas: toward European art, where a focus on the painting of Sigmar Polke, for example, displaced her earlier engagement with Salle; toward sculpture, installation works, and video pieces, which challenged traditional forms of collecting; and toward the younger artists who were coming into their own in the latter part of the 1980s. In these endeavors she was more than ever on her own, as the onset of serious illness in the mid-1980s began sharply to restrict her husband's ability to travel or visit galleries.

Still leery of focusing her efforts too narrowly, Mrs. Dannheisser had nonetheless determined that she could only shape the kind of collection she wanted through multiple acquisitions of the artists on whom she chose to focus, following their careers and representing each in depth. This meant, in practical terms, that she would need to be involved in several sectors of the market at once, and to balance relationships with many different players in an often competitive nexus of dealers and creators. She set out to acquire the work of Bruce Nauman, for example, not only by purchasing challenging pieces like the 1988 video installation *Learned Helplessness in Rats (Rock and Roll Drummer)* directly from an exhibition at Konrad Fischer's, but by seeking out other key pieces such as *White Anger, Red Danger, Yellow Peril, Black Death*, of 1984, on the resale market, through another dealer. Visiting the posthumous retrospective exhibition of Joseph Beuys in Berlin, she took the opportunity of a chance encounter with a Munich dealer to acquire his 1971–84 vitrine *Celtic*. At the same time, she made key commitments

to emerging artists, and then stuck with them. Mrs. Dannheisser was the first collector to purchase one of Jeff Koons's floating-basketball pieces (*Three Ball 50/50 Tank*, 1985), and she then proceeded to buy a work from each of the artist's subsequent exhibitions up until 1991. Similarly, she purchased her first work by Robert Gober directly from the artist's studio, then went on systematically to form an in-depth ensemble of Gober's work in diverse media as his career grew.

These concentrations did not impede Mrs. Dannheisser, however, from continuing to follow her instincts with regard to less-known artists, and she never ceased a broad range of one-time-only purchases when the work in question struck her as worthy. The in-depth collections of several artists that were the core of the collection were thus surrounded by a shifting field of acquisitions and sales that formed a testing ground for future development. And despite her ongoing commitments to particular artists, Mrs. Dannheisser rightly takes pride in never having "bought by name." That is, she focused intently on the pursuit of specific works, resisting opportunities or entreaties to content herself with alternative or substitute choices by the same person. She was also constantly faced with pressures to acquire works by other artists in a dealer's "stable" in order to assure herself of the opportunities to purchase the works she wanted from the artists on whom she concentrated. Her established pattern of advancing by sloughing off and selling works made her position, and her sense of timing, all the more delicate. In the process of negotiating her way through this problematic terrain, Mrs. Dannheisser stayed in constant touch with a small circle of friends whose interests paralleled her own, including, notably, the late Gerald Elliot of Chicago—whom she eventually joined on the Painting and Sculpture Committee of The Museum of Modern Art.

In establishing the space on Duane Street as in the way she shaped her acquisitions, Mrs. Dannheisser sought to operate outside the normal limits of a private collection and to emulate instead some of the traditional focus and public awareness of a museum, though working within a field of contemporary risk where few museums would move so decisively. Mrs. Dannheisser has, in fact, a long history of support for and involvement in museum life. During the 1960s and part of the 1970s, she was actively involved as a volunteer at the Whitney Museum of American Art, and at one point had

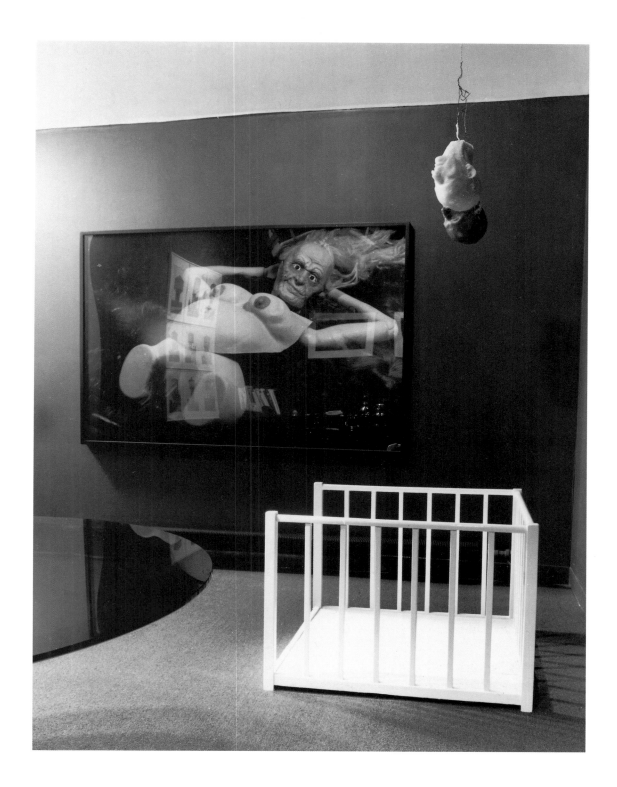

a desk in that institution's public relations office. In the 1980s, this allegiance shifted to the Guggenheim Museum, where she eventually became a member of the Board of Trustees; but after the departure of Thomas Messer, in 1988, her loyalty to the institution waned. She joined the Painting and Sculpture Committee of The Museum of Modern Art in 1990, and after extended discussion with the Museum's President, its Director, and curators from the Painting and Sculpture Department, in 1996 she resolved to donate the most substantial part of her collection to this institution. In that same year, Mrs. Dannheisser became a member of The Museum of Modern Art's Board of Trustees.

Robert Storr will provide a more extended discussion of the quality and interest of individual works in the Dannheisser Collection later in this book. In anticipatory overview, however, one should say that—to its great credit— this collection seems to have nothing "easy" about it. From its earliest moment, it has been the product of a constant process of change and refinement that has always pushed it toward more precise selectivity, more risk-taking engagement with recent art, and higher degrees of uncompromising toughness in the particular pieces selected. It is now filled with works that challenge a collector or an institution on several different levels. Many are difficult to present and all

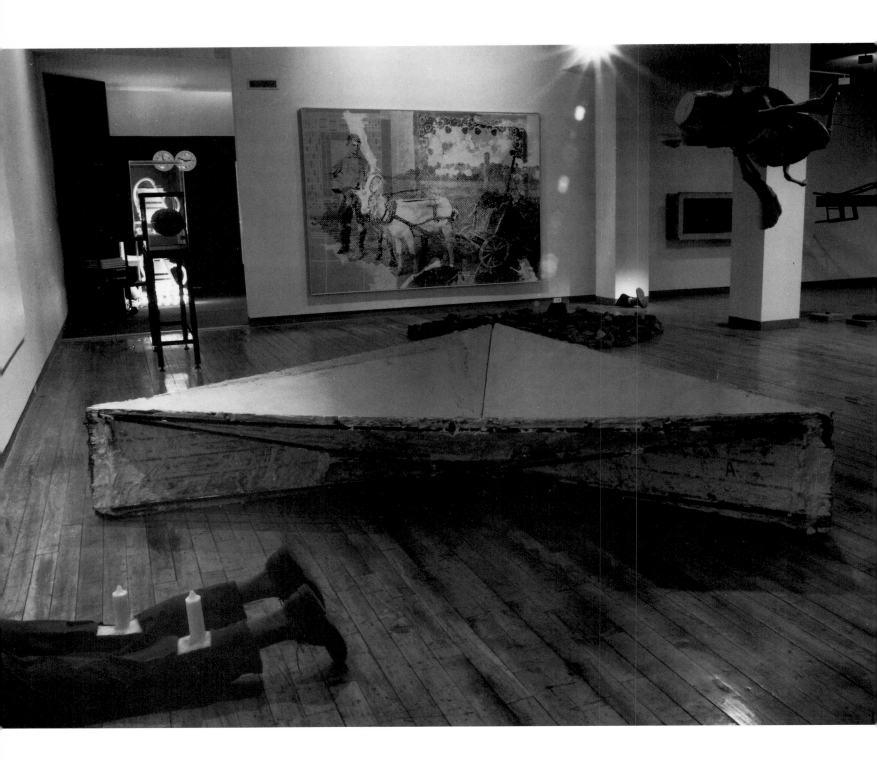

but impossible to "live with," as is the case with the assaultive Nauman video installations and huge sculptures, or perhaps even more literally so with Felix Gonzalez-Torres's untitled billboard work of 1991, which has no constant presence as an object and can only be "shown" by arranging for its public display. Scanning from this immateriality to the imposing weight and presence of Tony Cragg's *Oersted Sapphire* and Richard Serra's hot-rolled-steel *Melnikov*, both of 1987, and passing along the way both the gaudiness of Koons's *Pink Panther* (1988) and the austere elegance of the Brice Marden painting *Avrutun* (1971), one can easily see that this collection, in order to be coherent, serious, and distinctive, was never guided by principles of simplistic unity or harmony among its selections. Self-criticism, willingness to change, and a personally determined and steadily more demanding sense of quality have been its guiding mechanisms; and enjoyment of the process — of the anxieties, the gains and losses, the chases and captures, the play of personalities and objects — has been its constant spur.

Moving well beyond the limits of an ordinary domestic collection, yet acting with a combination of spontaneous risk-taking and ruthless pruning that no institution could easily match, Mrs. Dannheisser formed an ensemble of contemporary art that is exceptional in its combination of range and focus. She also found a great deal of pleasure in doing so. In recent years, since the death of her husband, she has slowed her activities both in traveling and collecting, but she remains strongly engaged with the life of contemporary art, and in fact strongly excited by what she sees. As an active gallery-goer, she feels that the later 1990s offer a range of new talents and new directions that promise a return to the level of activity and excitement she experienced in the heyday of the 1980s. Only time can prove this prediction, but the evidence before us suggests that betting against her intuitions would be ill advised. What is in any event certain is that the art world now emerging will be well served if it attracts new collectors as discriminating and as serious of purpose as Elaine Dannheisser has been; and that the public will be fortunate indeed if such collectors choose to follow the outstanding example of public-spirited generosity that she has established in assuring, through her donation to this Museum, that the works she assembled and cherished will be preserved and presented to our future visitors. We salute not only the wonderful quality of the artworks she has brought together, but also her personal tenacity, her acumen as it has evolved over decades of collecting, and the intensity of her engagement with contemporary art. We are tremendously pleased and grateful that her remarkable story has now come to join in the larger skein of histories of individual collecting, courage, and altruism that have informed the growth of this institution.

27 Duane Street, New York, with works on view by Robert Gober (see pp. 55 and 57), Robert Ryman (see p. 117), Jeff Koons (see pp. 77 and 79), Felix Gonzalez-Torres (see p. 64), Bruce Nauman (see pp. 98, 101, and 103), Sigmar Polke (see p. 111), Richard Long (see p. 83), Reinhard Mucha (see p. 91), and Carl Andre (see p. 20).

Werner and Elaine Dannheisser with Joseph Beuys at the Guggenheim Associates opening (October 31, 1979) of the exhibition *Joseph Beuys* at the Solomon R. Guggenheim Museum, New York (November 1, 1979–January 2, 1980).

Carl **Andre**

Richard **Artschwager**

Matthew **Barney**

Bernd and Hilla **Becher**

Joseph **Beuys**

Francesco **Clemente**

Sue **Coe**

Tony **Cragg**

Günther **Förg**

Katharina **Fritsch**

Gilbert & George

Robert **Gober**

Felix **Gonzalez-Torres**

Dan **Graham**

Andreas **Gursky**

Georg **Herold**

On **Kawara**

Anselm **Kiefer**

Jeff **Koons**

Richard **Long**

Brice **Marden**

Reinhard **Mucha**

Bruce **Nauman**

Sigmar **Polke**

Richard **Prince**

Robert **Ryman**

Richard **Serra**

Cindy **Sherman**

Thomas **Struth**

Michelle **Stuart**

Lawrence **Weiner**

Christopher **Wool**

Dates not inscribed on the work by the artist appear
in parentheses. Dimensions are given in inches (or, when
they include a measurement larger than ten feet, in feet
and inches), followed by centimeters in parentheses;
unless otherwise noted, height precedes width, followed,
where applicable, by depth. Unless otherwise indicated,
dimensions for works on paper refer to the full sheet.

Carl **Andre**

American, born 1935

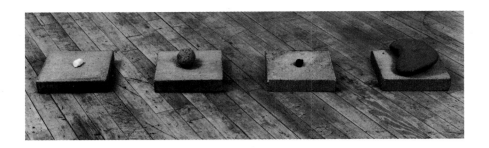

From the rigid male figures of earliest Greek antiquity to the elegantly simplified heads, birds, and pillars fashioned by Constantin Brancusi in the first half of this century, sculpture, when detached from architecture, has generally stood upright in our midst. It is, in a wisecrack usually ascribed to the abstract artist and wit Ad Reinhardt, "the thing you bump into when you back up to look at a painting."

Thanks in large part to the work of Carl Andre, this generalization no longer holds true. Instead, a sculpture may now be something you walk across, like a carpet; step up onto, like a patio platform; or wander through, like purposely scattered stones in a garden. Even if it should still crowd the gallery-goer or claim large segments of his or her territory, it does so as something not apart from but a part of his or her immediate reality.

Despite their obvious differences over the position and, correspondingly, the relative importance of painting and sculpture, Andre has always worked in tacit agreement with Reinhardt regarding the resolute nonreferentiality of modern abstract art. Just as Reinhardt's gridded pictures represent nothing, offering instead a unique experience of an externally bounded and internally ordered visual field, Andre's variously squared-off or irregularly scattered sculptures occupy and articulate physical space in a similarly austere but even more matter-of-fact way.

Andre's initial experiments of 1958–59 — patterned wood and Plexiglas pieces angled with a radial saw or bored with a drill — were made directly under the influence of Brancusi, to whose work he had been introduced as a high school student. At the suggestion of the painter Frank Stella, his friend and contemporary, Andre then abandoned the tradition of carving or cutting associated with Brancusi, but retained an intense interest in the Romanian artist's paradigmatic "Endless Column," realized as geometric totems of various heights that rose from the floor in modular units resembling stacked and truncated pyramids paired base to base.

Soon Andre recognized that by substituting unaltered industrial or construction materials such as railroad ties, firebrick, metal plates, and foam insulation-board for hand-tailored shapes, he could take the vertical seriality of Brancusi and make it horizontal. For *Primary Structures*, the seminal exhibition of Minimalist work mounted by Kynaston McShine at the Jewish Museum, New York, in 1966, Andre

contributed *Lever*, which consisted of 137 white lime bricks laid down on edge in a row leading up to a wall. It was, the artist said, "Brancusi's 'Endless Column' on the ground."

The essence of Andre's innovation was to establish a strong sculptural presence without recourse to traditional monumentality. Instead of building up, as artists of the past as well as he himself had once done, Andre built out. Instead of confronting the public with static monoliths, he created markers and zones around and through which people would move, thereby becoming active protagonists in the work rather than passive viewers of it.

Although Andre may be credited as one of the first artists of his generation to explore the possibilities of the random distribution of objects in space — he executed the first such "scatter" piece in 1966, the same year as *Lever* — the vast majority of his sculptures have been based on the sequential and often plainly symmetrical deployment of a given set of standardized components. These elementary but imposing compositions frequently recall the similarly emblematic configurations found in Stella's black, aluminum, and copper "stripe" canvases of 1959–61, signaling the extent to which Minimalism depended upon precedents in painting even though its sculptural manifestations seemed to dominate the tendency as a whole.

Of comparatively recent date, *Smithereens* (1984) nevertheless conforms closely to this model. Consisting of 210 bricks of the same basic type used in *Lever*, *Smithereens* is a bright corrugated expanse subdivided into regular intervals of blocks abutted end to end and set either flat or at a right angle, on their side. The fourteen parallel channels that result from this arrangement hold the floor but — unlike Andre's flat steel, lead, and copper checkerboards — do not share equal footing with it. Denied access to the area rigidly apportioned by the brick courses, one circumambulates and looks down upon it much as one would advance toward, withdraw from, and scan a mural relief — except that the shift in orientation from wall to floor subtly but fundamentally changes one's apprehension of and response to the grid. Thus a rectangle that seen frontally would appear equilateral is slightly skewed by perspectival recession when viewed from above. Instead of suggesting a sublime openness, moreover, as it might when approached head-on, the white field set in our path presents itself as a dazzling but obstructive reef.

4 Blocks and Stones (1973) is by comparison a small chain of islands, once belonging to a much larger archipelago entitled *144 Blocks and Stones*. Here, each one-foot-square concrete block acts as the base for a stone that the artist has selected for its particular characteristics, setting mass-produced uniformity off against natural uniqueness and diversity. All in all, however, Andre's many permutations of his basic formats demonstrate the degree to which variety is intrinsic to mathematically based systems. If the crystalline structures of rocks fascinate us with the range of their recombinations, Andre's deceptively obvious geometric manipulations can be no less striking in their nuanced differences. In the conceptual as well as the perceptual possibility for such finely drawn distinctions lies the Minimalist's art.

Carl Andre. *4 Blocks and Stones*. (1973.) Concrete blocks and river stones, each block c. 2½ x 12 x 12" (6.3 x 30.5 x 30.5 cm); overall: 5½ x 72 x 12" (14 x 182.9 x 30.5 cm). Gift of Werner and Elaine Dannheisser

Carl Andre. *Smithereens*. (1984.) 210 cement blocks, each 3⅝ x 7⅝ x 15½" (9.2 x 19.3 x 39.3 cm); overall: 7⅝" x 13' 5⅛" x 9' 1⅜" (19.3 x 409.3 x 277.8 cm). Gift of Werner and Elaine Dannheisser

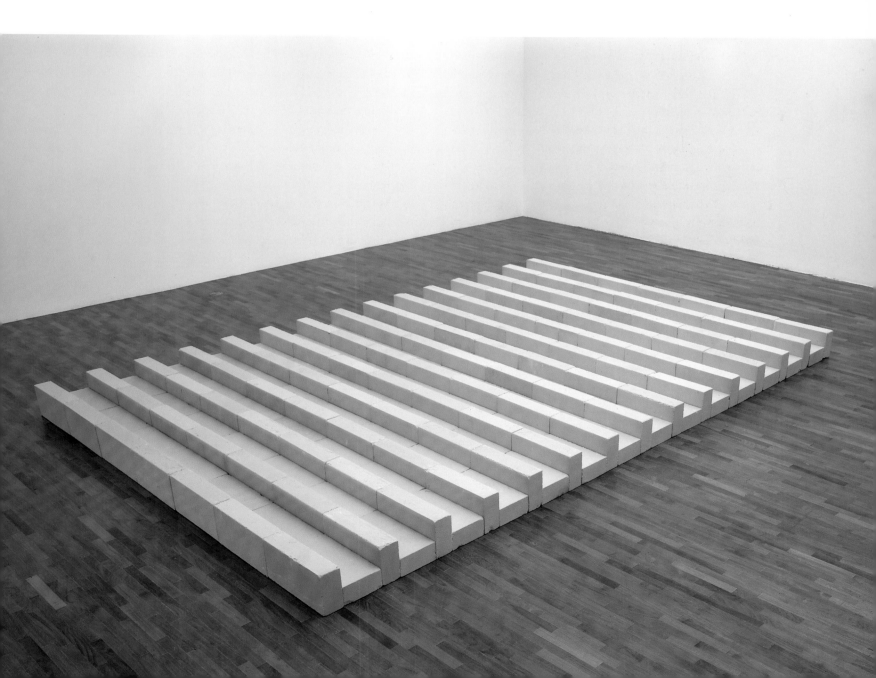

Richard **Artschwager**

American, born 1923

Richard Artschwager is a philosophical cabinetmaker. He is also a painter, though his pictures often have the appearance of furniture. His is a strange vocation, but it is not unprecedented in the history of American art. The suburban aesthete Joseph Cornell was the jewel box–maker of this tradition; the exmarine, ex–carnival acrobat, and obsessive carpenter H. C. Westermann was its master joiner. Both these artists drew on the formal language of classic Surrealism, Cornell speaking it with the uncanny fluency of a spiritual expatriate who never left his home in Ozone Park, Queens, Westermann translating its francophone poetics into slangy but word-and-image-perfect visual puns of a strictly all-American type.

Artschwager brings to the table another accent, though his and Westermann's experiences in several respects run parallel. Like Westermann, he saw action in World War II; like Westermann, he found himself slowly, working in obscurity at the margins of the art world for years before making his independent vision public; and, like Westermann, he just plain worked — designing and making furniture to keep himself going. This artisanal bent, the manufacturing principles he learned and adapted to his special purposes, and the materials he discovered and added to the repertoire of contemporary art practice are at the foundation of Artschwager's idiosyncratic endeavor.

Thus Formica, a slick synthetic replacement for just about any natural substance — wood, marble, metal — entered his vocabulary through his job finishing household interiors with countertops and storage spaces. Celotex, a compound construction-board with molded textures, came to his attention later, when he saw a work painted on it by the Abstract Expressionist Franz Kline; as with Formica, however, the material caught his fancy precisely because it replaced one "real" thing with another "ersatz" one. Automatically giving a thick impasto quality to the most glancing of brushmarks, Celotex's whorling pattern provided the ideal surface for instant rather than authentically arrived-at painterly bravura. And so, when a disastrous studio fire gutted his cabinetry shop in 1958, Artschwager simply shifted his focus away from the applied-art uses of these new materials to previously unimagined or untested "fine art" applications.

The first objects Artschwager produced in Formica came in 1962. The first paintings he executed on Celotex followed in 1963. The objects resembled chests of drawers, tables, and chairs, while at the same time gently mocking the "pure" geometry of contemporary Minimalist work by artists such as Donald Judd. Accordingly, an imitation-mahogany-grained cube would be inset with a white square, mimicking a linen tablecloth, or a beveled rectangle surrounding a recessed monochrome tablet of Celotex would evoke abstract painting by reducing it to its display format.

Exhibited in 1965, when the Pop art movement was at its peak, Artschwager's sculptures were admired exceptions to the rule of Pop's easily legible graphic style. Perhaps closer in spirit to Jasper Johns's work, they announced that they were not what they looked like, but they looked like that thing all the same. Indeed they were the distilled essence of the broad category of objects to which they referred, and what could be more anomalous next to an ordinary chair than an Ur-chair, or next to an ordinary dresser than an Ur-dresser? Artschwager was rearranging the mind's furniture.

Artschwager's paintings also have a Pop aspect, akin to the coolly off-putting icons of Andy Warhol. Originally derived from discarded snapshots that he retrieved from a trash pile near his studio, they were additionally precursors of Photorealism, the impact of which would increasingly be felt at the end of the 1960s. Using charcoal and black acrylic pigment, Artschwager transposed his found images onto his ready-made painterly grounds of silver-, white-, or gray-primed Celotex. The results were ghostly, out-of-focus pictures that seem to float in a mental and sensory middle-distance, halfway between recognition and dissolve, individuality and stereotype, figuration and abstraction.

The Organ of Cause and Effect (1981) combines painting and sculpture in a characteristically dense Artschwagerian hybrid. The edges of the work's heavy frame are inset to either side with mirrors that obliquely pick up the central image and bounce light back onto it and onto the surrounding wall. Within this frame, the grisaille rendering of the tree above graphically reflects that of the tree below, just as the roots that extend onto the slanted upper and lower lips of the support repeat those on the central picture plane. But not exactly. Simultaneously invoking the legendary Yggdrasil or world tree of Norse myth, whose roots reach to the underworld and whose branches touch the heavens, and the notion that a tree's foliage equals the proportions of its subterranean grasp, Artschwager sets up a visual chain reaction of imperfect

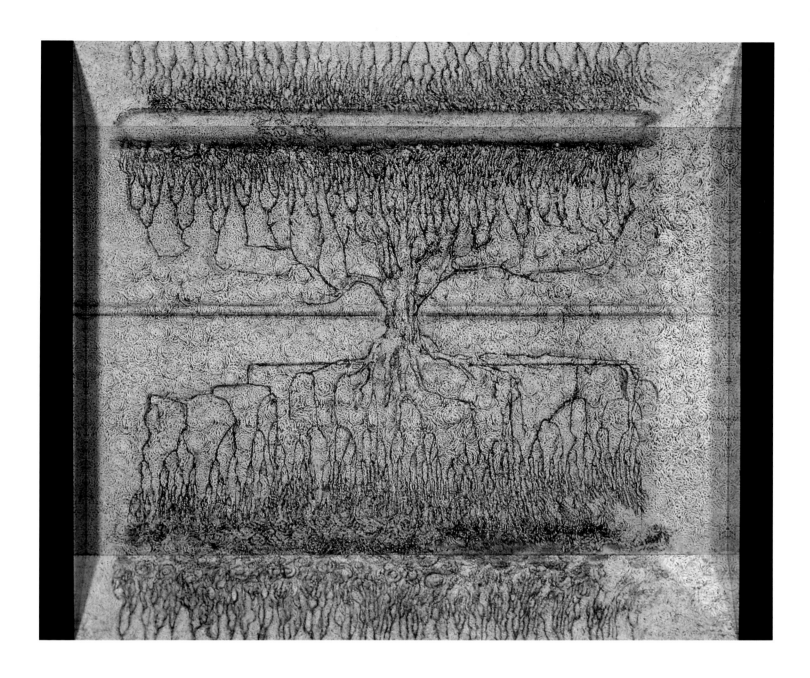

Richard Artschwager. *The Organ of Cause and Effect.*
(1981.) Synthetic polymer paint and charcoal on
Celotex with mirrors, 69¾ x 81½ x 11⅛" (177.2 x 207 x
28.2 cm). Gift of Werner and Elaine Dannheisser

symmetries in which cause does not quite match effect. Or is
it the symbol of a dualistic universe of barely differentiated
but infinitely repeated opposites?

These are only two ways of deciphering this powerfully
ambiguous work. Others are equally possible, since one can
never be absolutely sure of Artschwager's intended meaning.
He is a shaper of enigmas, and the precise status of his work

is, by rigorously crafted design, always in question. Moreover,
despite his on-again-off-again associations with Pop,
Minimalism, Photorealism, and other recent tendencies, he
remains aesthetically unclassifiable. No longer hovering
around the edges of the contemporary scene, yet impossible
to pin down, he is a maverick in the middle of the herd.

Matthew **Barney**

American, born 1967

Fred Astaire was an Olympian of no-sweat exertion. His fluid motion defied the laws of nature and, occasionally, those of gravity. Take *Royal Wedding*, for example, Stanley Donen's Technicolor confection of 1951, in which Astaire tapped his way up the walls and down again, and betweentimes literally danced on the ceiling. This choreographic inner-space-walk was all grace and effortlessness. The indoor mountaineering that brought Matthew Barney to the attention of the public in 1991, on the other hand, was effortful in the extreme, but in its fashion was no less improbable than the Donen sequence, and no less elegant either.

For his first shows in Los Angeles and New York, Barney rigged the ceilings of each gallery with climbing hooks, strapped his naked body into a harness, and clambered from one side to the other dangling from alpine clamps. A well-scrubbed Adonis in clinically white sadomasochist trappings, he took as much pleasure crossing the room the hard way as Astaire had in making his weightless act look easy.

That Barney is mindful of Hollywood movie musicals is evident from *CREMASTER I* (1995), a Busby Berkeley–inspired installation based on a five-part film project cryptically named by the artist after the abdominal muscle that raises and lowers a man's testicles. An affinity for cinematic camp was there from the beginning, however, as was a stylish delight in sexual double entendres. Thus *DELAY OF THE GAME (manual B)* (1991) shows a woman in a 1940s swimsuit, robe, bathing cap, and goggles languidly posed next to what appears to be a piece of athletic equipment. The woman, however, is a man, and the machinelike object — *Anabol (A): PACE CAR for the HUBRIS PILL* (1991) — is a simulacrum of a blocking sled used in football practice. Re-created in a pristine but mildly repulsive self-lubricating plastic, it luxuriates in technological decorativeness while also echoing Richard Artschwager's fascination with synthetic materials and finishes. The piece comes from an installation of the same name; the polyvinyl-framed photograph is from a videotaped performance in which the sculpture served as a prop.

These works, and the overarching project of which they are a part, strongly imply that a healthy body does not necessarily mean a healthy mind — not, at any rate, a healthy mind according to middle-class norms. Indeed such standards are precisely Barney's target. By equating the narcissism of the beauty queen with that of the macho football lineman — who

may also be a "queen," just as Barney's "pin-up girl" is also a "pin-up guy" — the artist neatly cross-references two American icons and conceptually cross-dresses them at the same time.

Both the football player and the mannequin represent physical ideals achieved through self-discipline or self-punishment: that of body-building in the first instance and of diet and grooming in the second. Neither kind of perfection is natural. Both hark back to the personifications of masculinity and femininity found in Greco-Roman art. To become a fully realized specimen of either type, one must suffer a transformative ordeal equivalent to rebirth.

That process — the passage from one state to another, from one gender to the other, or to yet a third, intermediate one — is an underlying theme of Barney's videos, including *DRAWING RESTRAINT 7* (1993). Here again — as in his reference to "hubris," the sin of envying the gods — Barney explicitly invokes ancient mythology, in which, of course, sexual metamorphoses frequently occur. During one half of the tape, a pair of satyrs on a empty stage grapple with each other, or with their own awkward bodies; during the other half, they struggle against each other and against the confinement of the limousine in which they are speeding across a city, over a bridge, and through a long tunnel, the latter in particular suggesting a birth-canal-like slippage from one reality to the next. Every gesture they make exudes entrapment, frustration, or erotic anticipation. Nearly identical in their two incarnations — the first hirsute, the second clean-shaven — these creatures remain oddly indeterminate, their genitals having been reduced to androgynous lumps, despite the obvious maleness of their heads and torsos. Like Barney's work generally, *DRAWING RESTRAINT 7* is a meticulously staged exercise in contradiction, without respite or resolution.

Viewing these fantastic but compellingly rigorous goings-on is like watching the arduous routines of earlier performance artists such as Bruce Nauman, Chris Burden, Vito Acconci, or Carolee Schneemann being rehearsed by neoclassical characters out of a Jean Cocteau film. It is a strange experience, to say the least. But in concentrating on fetishistic ritual and masquerade — that is, on bodily fixation, disguise, and display — while ratcheting up the tension between psychological mutability and biological resistance to it, Barney has pushed discussion about the balance of power between nature and culture, authenticity and artifice, to its

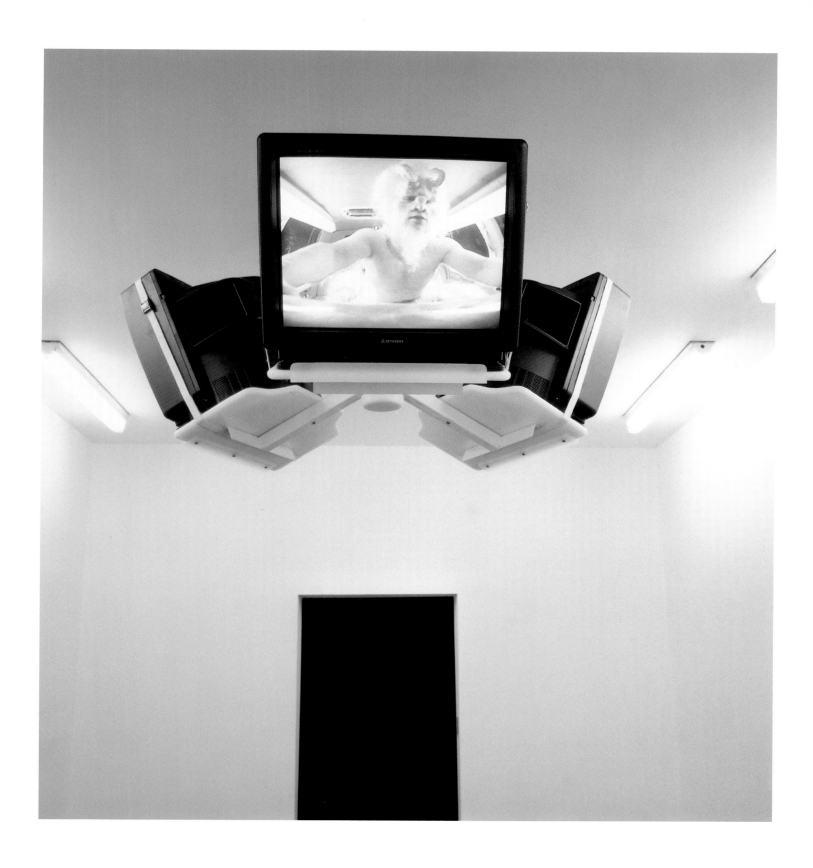

most theatrical point yet. Entering a crowded field of artists long preoccupied with these matters that includes Francesco Clemente, Gilbert & George, Robert Gober, and Cindy Sherman, among others (see pp. 36, 46, 48, and 122), Barney is fast staking his claim as the most aggressive aesthete among them, an art-for-art's-sake absolutist ready to remake the world in his own, changeling image.

Matthew Barney. *DRAWING RESTRAINT 7*. (1993.) Installation: three color video monitors, three laser-disc players, three laser discs, steel-and-polyethylene monitor bracket, and six fluorescent lights and fixtures, dimensions variable, central unit overall: c. 30" (76.2 cm) high x 44" (111.8 cm) diameter. Edition: 1/3. Gift of Werner and Elaine Dannheisser

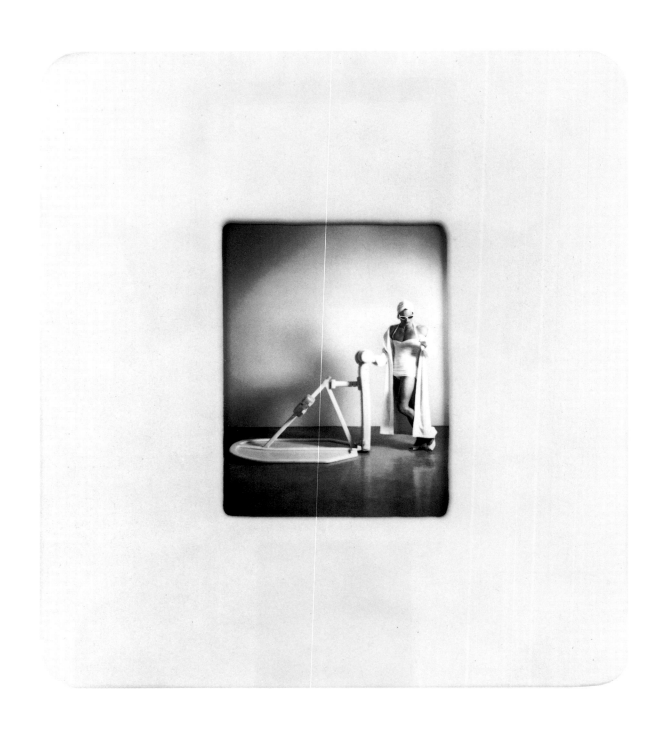

Matthew Barney. *DELAY OF THE GAME (manual B)*.
1991. Black and white photograph in self-lubricating
plastic frame, 14⅜ x 13 x ¼" (37.2 x 33 x 0.6 cm) .
Loan to The Museum of Modern Art, New York,
from Elaine Dannheisser

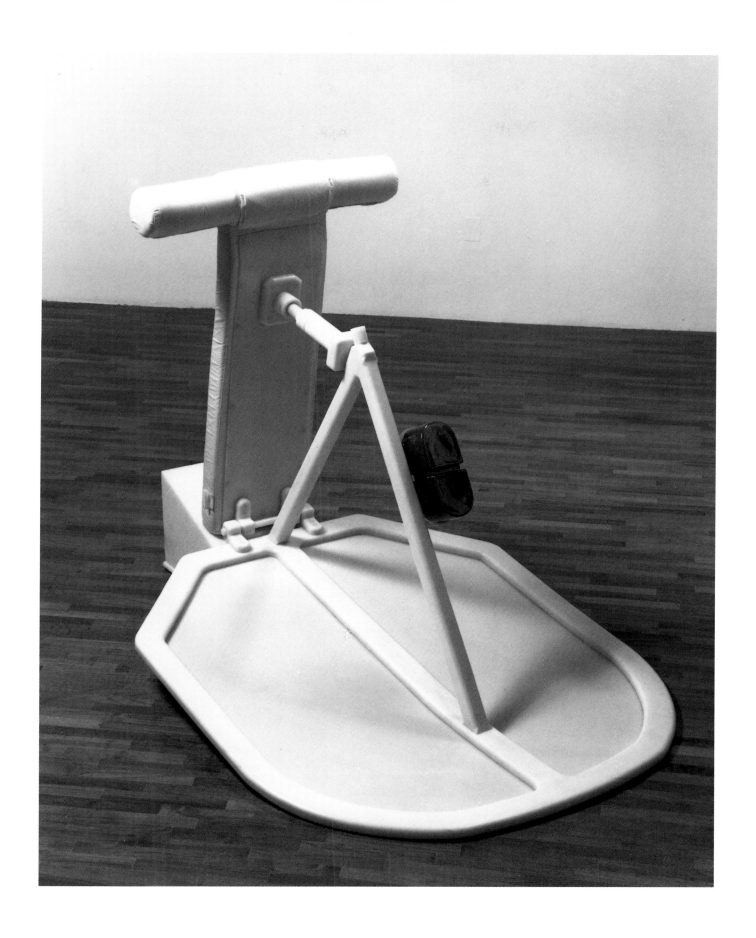

Matthew Barney. *Anabol (A): PACE CAR for the HUBRIS PILL*. 1991. Internally lubricated plastic, cast-sucrose capsule, and thermal gel pack, 53¼ x 76½ x 48" (135.2 x 194.3 x 121.9 cm). Loan to The Museum of Modern Art, New York, from Elaine Dannheisser

Bernd and Hilla **Becher**

German, born 1931, 1934

The art of the architect and the craft of the builder are not easily separated in the modern era. "Form follows function" was the credo of modernist architecture, and this belief pushed those who professed it far into the field of operations that at an earlier time was generally overseen by the engineers and designers of the industrial revolution's infrastructure. Not that the plants, warehouses, water towers, derricks, and housing stock erected under pressure of economic expansion were without their own aesthetic; even the strictest utilitarian demands or the most rigid vernacular conventions make allowance for formal invention. Within each basic prototype, there is room for differences based on the particularities of the site, the available materials, alternative methods of fabrication, and, not least, the taste of the blueprint draftsman, construction chief, or client.

For the most part, however, the monuments of modern builders have been passed over by both expert and amateur enthusiasts of modern architecture. The efforts made to protect masterpieces by Frank Lloyd Wright, Erich Mendelssohn, or Walter Gropius have not been matched in the case of obsolete depots or gas tanks. And when photographers have looked away from the dramatic contours of skyscrapers or showcase homes and gazed on such commonplace structures, it has usually been with an eye for their narrative interest, or for the ways in which they lend themselves to formal recomposition in the camera lens.

Into this gap stepped the husband-and-wife team of Bernd and Hilla Becher. Bernd Becher's earliest photographs, from the 1950s, were arrestingly deadpan descriptions of mineheads and similar facilities. In the late part of that decade, after he had joined forces with Hilla Becher, the couple together began to arrange such images in series according to functional category, and by the mid-1960s they were ordering them in uniform formats, so that each picture was aligned with the others in the sequence or block, and could easily be compared with them. The nine separate frames in *Water Towers* (1988) invite just this sort of scrutiny, each of the towers being unique unto itself but demonstrably similar in overall configuration to its neighbors.

Locking their pictures into grids in the manner of the experimental motion-photographer Eadweard Muybridge, the Bechers nevertheless use such coordinates to emphasize the static presence of their generally ignored subjects, which they might almost have marshaled into blocklike close formation to slow the hasty viewer down. Yet in emphasizing subtle and not-so-subtle variations in shape, these systematic layouts may, in a quick glance along any given axis, take on a strange metamorphic quality, as if one were watching the gradual evolution of an organic species.

The Bechers' obsession with structural morphologies recalls the Zola-esque sociological classifications of the German photographer August Sander, whose work was a major influence on them. Sander's seminal project *Menschen des 20. Jahrhunderts* (Citizens of the twentieth century) — published in an abbreviated album in 1929 as *Antlitz der Zeit* (Face of our time) — documented people of every social stratum in the same way that the Bechers portray their built environment. With keen eyes for the revealing feature, the Bechers are in effect physiognomists of vernacular architecture.

At the same time, though, their devotion to systemic analysis parallels that of Minimal and Post-Minimal artists for whom questions of mathematical set theory and of the variability of related modules were central, form-generating issues. Taken together, the Bechers' formalist methodology and strictly factual orientation toward the individual objects of their attention — not to mention their pervasive influence on the host of younger artists they have taught (see the discussions here of Andreas Gursky, p. 68, and Thomas Struth, p. 128) — have earned them a unique status among their contemporaries, while placing them in a special position where the distinct concerns of architecture, traditional photography, programmatic abstraction, and conceptual art meet.

Bernd and Hilla Becher. *Water Towers*. 1988. Unique work comprising nine gelatin-silver prints, each 15 ¹⁵⁄₁₆ x 12⅛" (40.5 x 30.8 cm). Fractional gift of Werner and Elaine Dannheisser

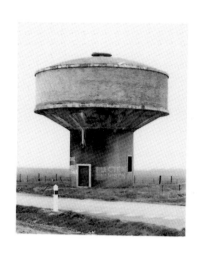 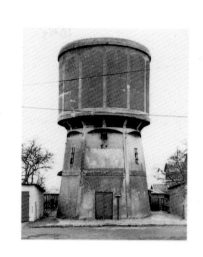 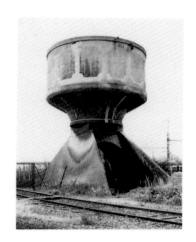

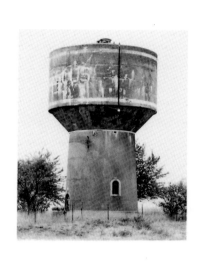 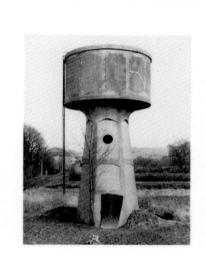 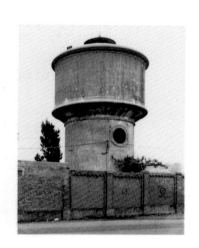

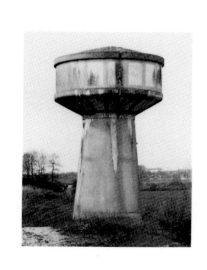 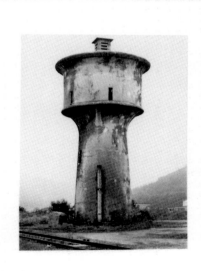 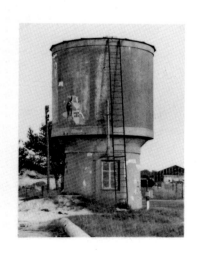

Joseph **Beuys**

German, 1922—1986

No figure looms larger on the horizon of postwar European art than that of Joseph Beuys. A product of historic tensions and catastrophes, and of a complex fusion of anachronistic notions and contemporary attitudes and opportunities, the Beuysian aesthetic is without parallel on this side of the Atlantic. Although his name has belatedly become known to Americans, his work and ideas have remained generally unfamiliar to them, which underscores the importance and the rarity of the pieces in this collection. The degree to which Beuys has been ignored or misunderstood in the United States is perhaps the clearest indication of the divergence between the formalist ideas about art and its function that continue to be widely held in this country and the less formalist assumptions that are more common abroad.

Born in the provincial German city of Krefeld, then moving with his family to the even smaller town of Kleve, Beuys spent his semirural boyhood caught up in the romance and mysticism of the back-to-nature movement that flourished in Germany in the first part of this century. Coming of age in the shadow of the Nazis' rise to power in 1933, he briefly joined the Hitler Youth, which turned earlier generations' fascination with Teutonic lore, collective living, and pastoral tradition to sinister ends. (His subsequent involvement with student politics in the 1960s may in part be seen as an attempt to undo this perversion of a once idealistic tendency.) In 1940, Beuys was drafted into the air force. He later served as a bomber pilot on the Eastern Front, where he was shot down in 1943.

According to his own, often disputed account, Beuys was rescued from this plane crash by a primitive tribe of Tatars who cared for his injuries by swaddling him in felt and fat. Whatever the facts of the matter, this incident, the ritual cure it involved, and the materials associated with it were to be essential to the personal myth and almost sacramental methods characteristic of Beuys's mature art. That maturity was slow and painful to come. After resuming civilian life, and having rediscovered his childhood interest in drawing local flora and fauna, Beuys entered the Düsseldorf Staatliche Kunstakademie in 1947, where he soon distinguished himself with carved or cast neo-Gothic crucifixes and animal sculptures. Haunted by the trauma of the war, in the mid-1950s he suffered a breakdown and, fueled by his reading of Karl Marx, James Joyce, and most especially the

spiritualist and reformer Rudolf Steiner, underwent what amounted to a conversion experience, emerging from it convinced that the goal of the artist was not simply to make aesthetic objects but to apply his talents to what he called "social sculpture." By this Beuys meant a total transformation of all existing social, political, and cultural relations based on voluntary association and the free play of human creativity.

In short, the task of the artist was to remold the world. Only such a utopian undertaking offered any hope of healing the wounds caused by Hitler's tyranny, redeeming a nation tainted by guilt, and transcending the Cold War antagonism between capitalism and communism that pitted East against West and literally divided Germany. Or so Beuys believed. Acting on those beliefs with ever greater urgency and grandiosity in the thirty years between his ordeal and revelation of 1955–57 and his death in 1986, he created a vast and formally disparate body of work that encompassed drawings, paintings, graphics, photographs, unique sculptures, multiples, videos, and large-scale installations. Meanwhile, the profound influence he exerted in Germany extended from his role as a rebellious professor at the Düsseldorf academy, whose faculty he joined in 1961 and from which he was expelled in 1972 for siding with the burgeoning student movement, to his involvement in electoral politics as a founding member of the ecological Green Party and one of its candidates for office in 1979.

No American artist of the postwar era, nor any other European artist for that matter, announced so all-inclusive an ambition to dissolve all art into life. In so doing, Beuys hoped to abolish all the ideological distinctions that he held responsible for the authoritarian systems bedeviling the modern epoch, and to replace art-as-art with art-as-anthropology, art-as-therapy, and art-as-democratic-self-determination. The depth of his need to overcome the horror, shame, and cultural contamination of the Nazi past while setting the terms for a purified and more productive future may be measured by the messianic role he assigned himself. His pivotal position in all dimensions of German artistic and political life from the early 1960s onward testifies to the resonance, both positive and negative, of his message.

Formally speaking, Beuys's work owes its distinctive character to an unusual combination of early-twentieth-century

Joseph Beuys. *Schultafel* (Blackboard). 1974.
Blackboard drawing, c. 37⅛ x 48¾"
(94.2 x 123.8 cm). Gift of Werner and
Elaine Dannheisser

Dadaist procedures and nineteenth-century Symbolist poetics. On the one hand, much if not most of Beuys's sculpture exploits the surprising juxtaposition of found images and materials that was pioneered by Marcel Duchamp's readymades and assisted readymades. On the other hand, Beuys's themes hark back still farther to ancient Nordic mythology, the romantic literature of Goethe, frankly Christian iconography, the consecration of religious relics, and the occult.

Celtic (1971–84) involves almost all of these elements. It is one of fifty-three such glassed-in cases in which Beuys deposited artifacts associated with his various performances or "actions." Together these vitrines constitute an archive of his career, raising one of the key paradoxes of his counter-cultural stance: Beuys launched his revolution against the institutions of art from inside rather than outside those institutions, creating a new academy within the old, and inventing his own style of museum presentation—modeled on antiquated ethnographic or archaeological practices—in opposition to the clean white space of the modernist gallery.

The forty-third in the series, *Celtic* holds a cruciform stamp and a name stamp used to sign works in brown ink; a corked flask; a film canister; gelatin- and beeswax-covered photographs, both from the 1971 action *Celtic +*; and two basins, one used for washing feet, the other, so Beuys said, for

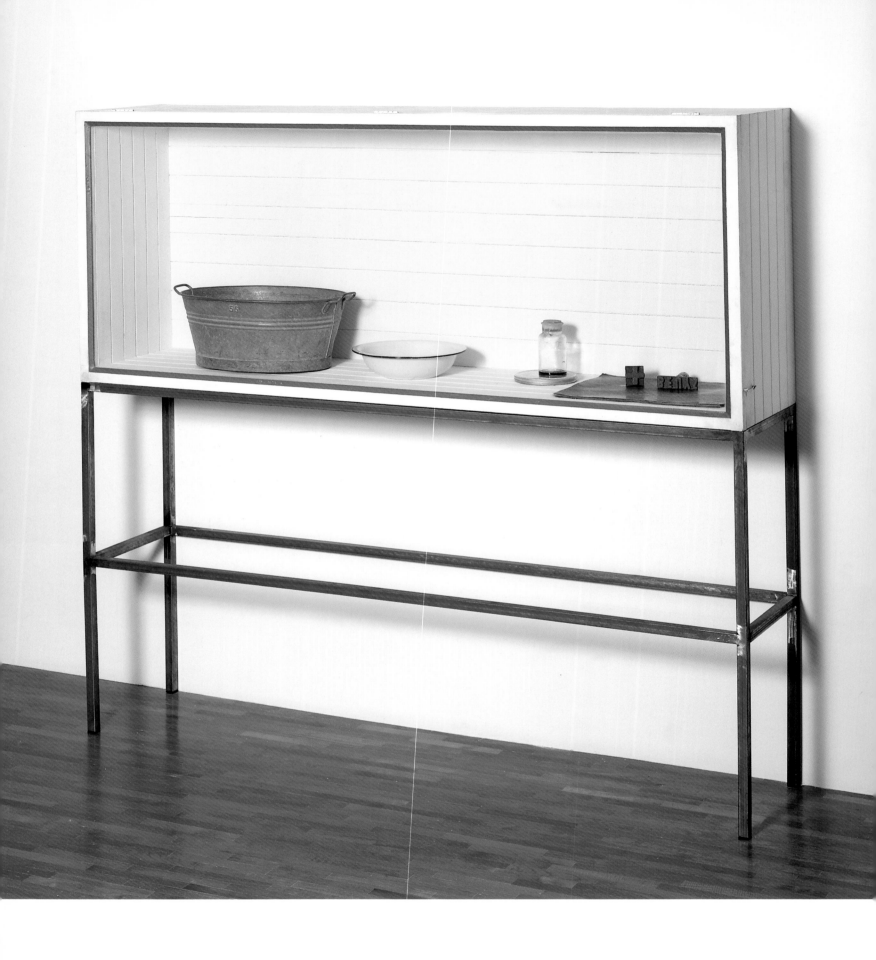

"Baptism." Mundane objects by all appearances, they constitute an allegorical still life referencing Beuys's Christ-like rites of self-anointing and self-humbling; or, as his fellow artist and steadfast adversary Norbert Kricke said, his "Jesus Kitsch." Those more charitably inclined toward Beuys's dramatizations recognized in them the aspirations of the traditional shaman. A metaphysical homeopath, the shaman — who, as Beuys did, customarily breaks with convention and professes a privileged closeness to nature — takes upon himself the ills of the group, suffers them on its behalf, and, in triumphing over sickness himself, banishes it from the community at large.

A much earlier piece, *Fat Felt Sculpture (Fat Battery)* (1963) is also presented in a museological vitrine. Employing the same materials in which Beuys claims to have been nursed back to health by his Tatar captors, this strange, dilapidated piece invokes the powers of folk medicine in a modern age while embodying Beuys's pseudoscientific theory of energy based on organic warmth — in this instance stored in melted fat and matted fiber — and its natural conservation and conductivity. *Gerolte Fahne* (Rolled banner, 1983) suggests similarly esoteric properties. As a symbol common to the ancient Celts, Aztecs, Chinese, and Egyptians, among others, the hare, a creature with which Beuys explicitly identified, generally personified the quick-witted trickster. In this case the hare's vital essence runs — like a martyr's blood — over a sheet of lead, the inert metal that alchemists tried to turn into gold. The result is an austere but arresting talismanic emblem.

Schultafel (1974) is an example of the numerous blackboard drawings that Beuys produced during the lectures he gave to propagate his holistic program. He used these "schoolboards" (which directly incorporate the ornate script and hieroglyphic diagrams of his role model, Steiner) to annotate his stream-of-consciousness monologues, writing equations to describe the social and spiritual transactions he wished to bring about under his new anarchistic order. One of a series of 100 such panels made during a 1974 visit to England, *Schultafel* is elegantly laid out, but its subject is obscure. Like most of Beuys's works, it survives as a physical remnant or ruin of his great and ultimately unrealizable conceptual edifice.

A modernist by virtue of his experimental approach to new media and his inventive re-use of established avant-garde techniques, Beuys was at heart a reactionary who wanted to save the twentieth century from itself by turning back the clock to a more innocent and coherent age that actually existed only in his imagination. His efforts may have been quixotic but the idealism that drove him and his acolytes was genuine, and the evidence of it to be found in these and other fragments of his protean output is of a unique and perplexing beauty.

Joseph Beuys. *Celtic*. 1971–84. Various objects in metal-and-glass vitrine, 81⅛ x 86⅜ x 19¾" (206 x 220 x 50.2 cm). Loan to The Museum of Modern Art, New York, from The Werner Dannheisser Testamentary Trust

Joseph Beuys. *Gerolte Fahne* (Rolled banner). (1983.)
Lead, hare's blood, glass, and steel, 30⅛ x 24 x
2⅜" (76.5 x 61 x 6 cm). Gift of Werner and
Elaine Dannheisser

Joseph Beuys. *Fat Felt Sculpture (Fat Battery)*. (1963.)
Fat, felt, and cardboard box in metal-and-glass vitrine,
44 x 27 ¼ x 34" (111.8 x 69.2 x 86.3 cm). Gift of
Werner and Elaine Dannheisser

Francesco **Clemente**

Italian, born 1952

A regular feature of modernist thinking is its claim of a linkage between the fact of change and the idea of progress. According to such logic, the task of the avant-garde — a name deriving from the military tactic of dispatching special forces to scout out unfamiliar territory — is not merely to create wondrous things but to advance the cause of art. By this definition, Francesco Clemente is not a modernist, though he is in every way an up-to-date contemporary stylist. One of the most innately gifted of the young artists who came to fore in the 1980s, he numbers among those "post-modernists" more inclined to look backward than forward, more disposed to ironic pastiche than to programmatic innovation. In fact Clemente seems oblivious to the notion that the world is subject to deliberate improvement, preferring instead to devote his multifarious talents as draftsman, painter, printmaker, and sculptor to recording the unceasing metamorphosis of the presumed constants of our lives, and the fundamental instability of the physical and philosophical environment in which those constants exist.

Clemente's fatalistic delectation of things in flux may in part be explained by a pluralistic worldview that is reinforced by migratory habits. A largely self-trained artist whose parents encouraged his adolescent forays into poetry and painting, Clemente grew up in Rome, a city built upon the rise, fall, and chaotic fusion of civilizations. A friend and protégé of Alighiero Boetti, a central figure in the Italian movement of *arte povera* (or "poor art," a tendency based on hybridized sculptural processes), Clemente traveled to Central Asia in the early 1970s, later returned on his own to become a connoisseur of traditional Indian painting and vernacular arts, and since 1980 has divided his time between Madras, New York, and his native city, Rome. Mercurial to begin with, then, Clemente's sensibility is capriciously multicultural as well. A believer in the natural or supernatural mutation of all that we know, he tracks the aesthetic reincarnation of primary motifs drawn from an exceedingly wide range of sources. In his work, antic descendants of Latin and Italian Renaissance grotesques mingle with ornamental Persian formats, borrowings from contemporary Indian graphic design, and sly references to or dazzling variations on the current fashions in "mainstream" art in Europe and the United States. (In this regard, also note Clemente's *Funerary Painting*, a 1988 artist's book, in this collection, devoted to his reworking of ancient renderings of the voyage of the dead; see p. 138.)

Clemente's choice of materials is consistent with this penchant for blurring historical periods and regional styles, while simultaneously playing fast and loose with the viewer's expectations regarding the specific identity of or meaning implicit in his heterogenous repertoire of religious, sexual, and psychological symbols. Master of a precise descriptive line, Clemente nevertheless favors mediums — watercolor, fresco (water-based pigments on wet plaster), and pastel — that allow for, even guarantee, that this line will bleed into other forms, or diffuse throughout the atmosphere in which it moves. Consequently, nothing it depicts is truly fixed; everything remains open to the possibility of dissolving into or becoming something else. In this sense, Clemente's aesthetic universe is characterized by its fundamental porousness; anomalous images commingle, and opposites unify or exchange qualities, as forms and colors meld into one another.

The untitled and undated pastel in this collection is a prime example of just such deliberate pictorial ambiguity. Here three figures are grouped together under a sweltering sun. Roughly contoured, out of proportion, and stridently colored on a cursory greenish ground, they recall Matisse's Arcadian bathers, dancers, and musicians of 1908–10 filtered through the jaundiced eye of Egon Schiele, the turn-of-the-century Viennese artist who has influenced Clemente in so many respects. Naked rather than nude — that is, stripped of their clothes rather than classically disrobed — they are linked by touch but otherwise seem isolated by their variously anxious or easy postures. The man in the foreground is contorted by an impossible rigidity, the man to the left gestures toward him from a yogalike sitting position that appears almost as tense, while the man standing above them strokes the head of his neighbor with an almost motherly tenderness. That movement of the hand causes one to reexamine what initially present themselves as the figure's male attributes, and on second inspection one realizes that the ample chest resembles a woman's breasts, while the hanging genitals are almost added on to the pubic triangle of a woman's lower body. These anomalies go unexplained in this drawing without stated theme or discernible setting, but that is the way with Clemente, who, while teasing categorical minds, is content to watch or provoke transformation for no other reason than that it is the law of the land of his fertile imagination.

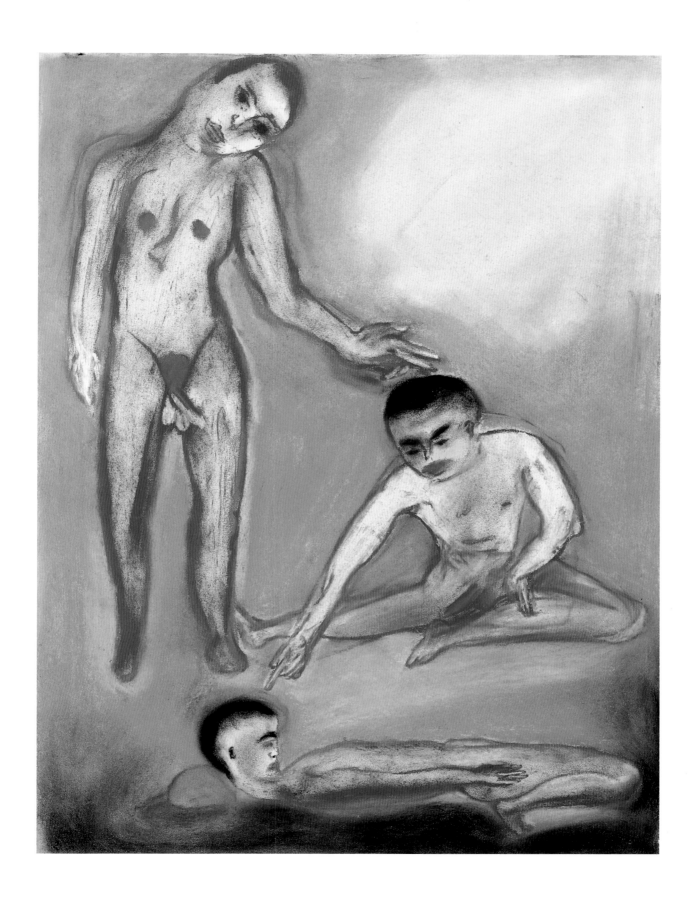

Francesco Clemente. *Untitled*. N.d. Pastel on paper,
23½ x 17¾" (59.7 x 45.1 cm). Fractional gift of Werner
and Elaine Dannheisser

Political art, if it hopes to be successful as either politics or art, must complicate rather than simplify understanding of the social realities upon which it focuses. Its contribution to civil discourse is to break open the reductive formulas around which partisan debate tends to fixate, and to articulate the ambiguities and contradictions that vex the always tense interplay between public forces and decision-making, on the one hand, and individual ethical or ideological choices, on the other. What dates political art more than its topicality is its rhetoric, and the unexamined assumptions revealed by its mode of address. To the extent that a great deal of this kind of work explicitly divvies up the world into "good guys" and "bad guys," the danger lies not just in misidentifying the villains or blindly celebrating the virtuous, but in failing to consider the problem of who the audience might feel it possible to be, or to think they are — "them" or "us." When art issues the old challenge "Which side are you on?," the seriously engaged artist must be prepared for the answer "Neither," or "Both."

That realization is at the root of much of the best socially oriented work of the last two decades. In America since the 1960s, the divided loyalties exposed by the war in Vietnam, the civil rights and black power movements, women's and gay liberation, and a host of other tendencies and events, have made moral certainties suspect even as they have increased the pressure on people to come to terms with painful truths about themselves and their country. The obliquity of the work of such socially committed artists as Felix Gonzalez-Torres acknowledges this situation without ceding to aesthetic obscurantism or intellectual relativism. If sides must be taken, such art recognizes, not everybody will know with certainty where they stand, and in those instances when they do, it may not necessarily be obvious to them how to proceed from there.

In this context, the brutal graphic statements of Sue Coe might at first seem almost throwbacks to an earlier, less doubting time. Coe's style and her artistic role-models reinforce that impression. In the doomsday darkness of the scenes she sets, the monstrous narratives she unfolds, and the harsh line and strident color with which she limns them, Coe openly invites comparison to the Mexican painter José Clemente Orozco, the Weimar artists Georg Grosz and Otto Dix, and the Social Realists of Depression-era America. Even so, Coe's work very much belongs to its own moment and milieu. Born in England into a working-class family, she attended the Royal College of Art on a scholarship, then moved to New York in 1972, a period of intense crisis in U.S. politics. Almost immediately Coe made a name for herself by drawing for the op-ed page of the *New York Times* and other mainstream publications, but within a few years she had established herself even more firmly among the ranks of young artists exploring the opportunities offered by the alternative press and underground "comix." Notable among her contributions to this genre are her book-length works *How to Commit Suicide in South Africa* and *X*, both published by Raw Books and Graphics, the brainchild of cartoonist Art Spiegelman, author of the paradigm-smashing Holocaust "comic" book *Maus*.

Like many of Coe's drawings, *Woman Walks into Bar — is Raped by 4 men on the pool table — while 20 watch* (1983) takes off from the headlines. Indeed the incident on which it is based, which occurred in a bar in New Bedford, Massachusetts, made the national news, the tensions it raised being exacerbated by the neoconservative backlash against feminism that began in the early 1980s. The largest of the several versions of the subject Coe made, the work in this collection is also the most complex, both formally and thematically. Patched together in sections, as if an early Soviet poster montage had been redrawn by a punk-rock caricaturist, this work on paper is a composite of fervent story-telling, horrific pictorial invention, and polemical asides. Thus grotesque bystanders look on at the bestial violence like a guilty Greek chorus — and, so doing, put the gallery viewer in the unwanted position of complicitous voyeur — while to the right of the rapist's naked buttocks the front page of a tabloid announces the shooting down of a civilian jet airliner by Russian fighter planes.

Coe is a sophisticated practitioner of the most easily abused subgenre of political art: protest art. To be effective, protest art must to go extremes in depicting injustice and inhumanity, yet by that very token is virtually guaranteed to indulge in the sort of Manichaean simplification of issues that will limit its social reach and conceptual scope. The trade-off is impact. Human emotions are rarely self-sustaining, even those as powerful as fear or anger. Knowing this, the protest artist applies the electrodes of rage to the heart and nerves, with the aim of stirring consciousness. Repetition of this therapy may threaten to numb the respondent, but the history of art contains ample proof that despite

Sue Coe. *Woman Walks into Bar — is Raped by 4 men on the pool table — while 20 watch*. 1983. Mixed mediums collage, 91⅝ x 113¼" (232.7 x 287.6 cm). Loan to The Museum of Modern Art, New York, from Elaine Dannheisser

our repeated exposure to certain images, and despite changes in the world that may render such images anachronistic in their detail, some works that were intended to cause as much hurt as they described still do.

Coe's pictures, *Woman Walks into Bar* in particular, are hard to take in just this way. One wants to look away, but can't help looking; and having eventually looked away, one wants to dismiss the awful things seen, but can't help remembering them. If Coe weren't so good at what she does, one wouldn't feel so badly about having borne witness through her eyes to the wretchedness she portrays, or so aesthetically conflicted about the passionate ugliness of her expression.

Tony **Cragg**

British, born 1949

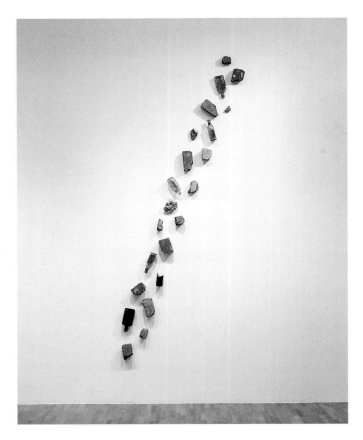

Tony Cragg. *Bricks and Bottles*. (1982.) Brick and glass, overall: 114¼ x 43 x 3" (290.2 x 109.2 x 7.6 cm). Gift of Werner and Elaine Dannheisser

In the 1960s, two men dominated the debate over the direction of sculpture in Great Britain while contributing in a major way to similar debates worldwide: Henry Moore, the master carver and modeler who modernized large-scale figuration, and Anthony Caro, his former studio assistant, who reduced the mass of the traditional monument to a scaffolding of volumeless planes, screens, bars, and beams. Following the lead set by his American mentor David Smith, Caro also took sculpture off the pedestal on which it had remained even after Moore's many formal manipulations. In short order, Carl Andre pushed this move still farther with the regularly or randomly distributed floor pieces he began to show in New York in the mid-1960s (see p. 20).

From Moore's definition of sculpture (the shaping of a free-standing three-dimensional image) to Caro's (abstract compositions often projected into space) to Andre's (the arrangement of simple modules on a two-dimensional surface, these units being as earthbound in their way as Moore's monoliths had been in theirs), an extraordinary panoply of choices opened before the generation of the 1970s to which Tony Cragg belonged. Over the course of a career that now stretches some thirty years, Cragg has taken advantage of the full scope of these options, producing a large and idiosyncratic body of work that encompasses solid objects at times oddly reminiscent of Moore's, repeatedly perforated ones that gently toy with Moore's pierced biomorphs, exploded assemblages that return Caro's elegant formalism to the realm of Pop appropriation, and graphic reliefs that move back and forth from floor to wall in wry imitation of Andre's Minimalist "carpets" and scatter sculptures.

Bricks and Bottles (1982) and *Oersted Sapphire* (1987) represent the extremes of this broad aesthetic span. The former is composed of found objects of the two types named in its title. As early as 1973, while still a student at London's Royal College of Art, Cragg used brick fragments to construct towers that leaned precariously against the wall, in obvious homage to both Andre and Constantin Brancusi. By 1980, he had begun to make polychromed silhouettes out of plastic containers and other scavenged materials, thereby combining aspects of drawing, signage, painting, and collage in what would rapidly become a hallmark style. With its unenhanced components and unspecific contour, *Bricks and Bottles* occupies a position somewhere between Cragg's early process-art

pieces and his subsequent neo-Pop ones. While the green glass catches and refracts the light, the opaque bricks throw irregular shadows on the wall, multiplying the optical dimensions of a piece that is in reality made up of relatively few, intrinsically unprepossessing elements. Like Cragg's work of this kind generally, this meteor shower of shapes traces the transformation of dull junk into memorably emblematic configurations. It is recycling as a fine art, which is a laughable premise only on the condition that one first appreciate the wit of the artist involved.

The multipart cast-aluminum *Oersted Sapphire* offers an altogether different sculptural experience. Of Brobdingnagian proportions, the six vessels that compose the ensemble suggest a giant laboratory set, or an alchemist's paraphernalia. Before becoming an artist, in fact, Cragg had worked for several years as a research biochemist, but had rebelled against the abstractness of science. Flasks, test tubes, specimen jars, and crucibles frequently appear in his more recent work, however, as if, like the sorcerer's apprentice, he had worked a kind of magic over the tools of his former trade, making artful fantasy out of what had once been for him a torment of experimental exactitude. Whatever his personal motives, these oversized shapes confront the dwarfed viewer with a combination of mystery and menace (what

Tony Cragg. *Oersted Sapphire*. (1987.) Cast aluminum
in six parts, overall: 7' 6" x 18' 10" x 11' 1" (228.5 x
574.1 x 337.8 cm). Fractional gift of the Werner
Dannheisser Testamentary Trust and Werner and
Elaine Dannheisser

potent solutions do they or did they contain?), while at the
same time inviting one to walk among them and touch their
shining surfaces.

The disorientation these objects occasion, and the
narratives they imply, may be traced back to Surrealism,
which exerted a considerable influence on Moore and his
generation, even as one is also reminded of the work of
Claes Oldenburg, whose mammoth objects owe an equal
debt to Salvador Dalí and Walt Disney. But Cragg's sculp-
tures, usually big without being ungainly, have none of the

forlorn or comic quality of Oldenburg's, and none of the
dreaminess of classic Surrealism. Nor do they add up to
create a coherent alternative world; on the contrary, his
work's inconsistency is among its chief strengths. In the final
analysis the essential story that Cragg's art has to tell is that
of a perversely intelligent craftsman to whom nothing
formally imaginable is forbidden, and to whom nothing,
however improbable, is fully imagined until it has been given
tangible form.

Günther **Förg**

German, born 1952

Günther Förg's work takes several forms: paintings on canvas, paintings on paper, paintings on walls, paintings on lead, cast-bronze reliefs whose patterned surfaces look like death masks of paintings, free-standing monoliths or stelae of singular obdurateness, and large, affectless photographs of women and of architectural monuments of the modern era, such as *Villa Wittgenstein* (1986–87). Apparently disparate, every individual piece within Förg's diversified production may actually be viewed as both a monument to the modern era and a symbolic rejoinder to the ideological expectations that attached themselves to the originals he evokes. His paintings derive their spare syntax from the history of pure geometric art that begins in early Russian Constructivist and German Bauhaus styles and extends through Barnett Newman, Ellsworth Kelly, and the American hard-edge school; his reliefs make similarly obvious reference to the material, textural, or monochrome abstractions of such European avant-garde figures of the mid-century as Lucio Fontana, Piero Manzoni, Yves Klein, Jean Dubuffet, and Alberto Burri. As to his photographs, most of them are details of landmark architecture by the likes of Ludwig Mies van der Rohe, Walter Gropius, and, of course, the Austrian philosopher Ludwig Wittgenstein, whose contribution to the field consisted of the details he designed for the house built in Vienna in 1926 for his sister by Paul Engelmann, a disciple of the pioneering modernist architect Adolph Loos.

Like most of these photographs, *Villa Wittgenstein* is slightly grainy from enlargement, and difficult to see because of the glass in front of it. The expressive quality of the work resides in those apparent defects. Rather than permitting us to see architectures in their entirety, or even their signature profile, Förg shows us isolated sections, usually cropped in such a manner as further to obscure their identity, so that until we have read the work's title we are forced to guess at the whole from the parts. This metonymic game of hide-and-seek is compounded by the glass, which, because of its reflectiveness, further breaks up the unity of the images. In the case of *Villa Wittgenstein*, we find ourselves looking through this glass at a photograph of an interior glass door, through which, in turn, we see another glass door rendered semiopaque by the sun that shines through it into the villa. Depending on the gallery illumination, a similar glare will appear in the glazing of the framed picture, and depending on one's position in relation to the work, one may see oneself mirrored and thus relocated in an optical limbo between the space depicted and the physical space one actually occupies.

Precisely what space that is may also be an issue. Förg's pictures of the French windows at the Villa Wittgenstein were first exhibited in 1987 at the Museum Haus Lange in Krefeld, West Germany. The museum, initially built in 1930 as a private home, was among the early commissions of Mies van der Rohe. Originally, then, Förg's images of the Villa Wittgenstein were seen within the context of yet another modernist masterpiece.

By means such as these, Förg places us in a correspondingly ambiguous relation to the whole of the aesthetic tradition that he has appropriated with his camera. Förg's critical strategy centers on a kind of stone-faced quotation or paraphrasing. His pictures of the Villa Wittgenstein neither celebrate nor send up this icon of twentieth-century progressive architecture. Nor do his similarly neutral pictures of Italian neoclassical buildings comment on the fascist aesthetic tendencies of which they were prime examples. Förg's view of modernism is broad insofar as it encompasses these extremes, but narrow in that it focuses almost exclusively on such rationalist styles. Within this range he has created a dialectical tension between modernism as a humanist enterprise and modernism at the service of power. Clearly the latter interests him most. Moreover, he does not dispute the authority of the once dominant styles he re-presents. Emulating them, he contemplates the basis of that authority with a melancholy awe.

A chill pervades everything Förg touches. Whatever format he chooses, we see the disciplined but irrepressible energy of earlier avant-gardes diffused or congealed. This is intentional and its effect is disconcerting. In spectral variants of its once vigorous self, modernism, as replayed by Förg, still commands attention but offers no hope. His art is backward-looking without being nostalgic. The gods have forsaken us, Förg seems to be saying, and by no stretch of the imagination were they all benign. What remain of them are majestic emblems of a transcendence long promised but henceforth and forever to be denied.

Katharina **Fritsch**

German, born 1956

The sculpture of Katharina Fritsch is pristine and very strange. Sometimes grandiose and elegantly crafted, other times totally unassuming in size and facture (although no less painstakingly arrived at), her objects range from the fantastic to the eerily ordinary. Like Robert Gober (see p. 48), she is a perfectionist with ties to historical Surrealism — the highly selective, dreamlike focus of her imagination, and the extreme formality of the shapes she plucks from it. Unblemished by time or touch, the emblematic forms she sculpturally reproduces, as well as those she wholly conceives, seem to exist in an insular world all their own, yet, by virtue of their actual presence in ours, they stop us cold in the course of our casual inventory of the environment and demand to be looked at.

Dispassionate, exacting, and quietly weird, Fritsch's art runs contrary to the main neo-Expressionist or neo-Dadaist currents of German art in the 1980s and '90s. Her first mature sculptures were tabletop abstractions of everyday objects or structures: a piano, a piano with stairs cut into it, a tunnel, a chimney, a folksy rendition of an old mill, a car and trailer, a broom, and so on. Monumental despite their actual diminutiveness, these objects have an iconic stillness that harks back to the interiors of Edward Hopper, which Fritsch had admired when she worked as a painter before turning to sculpture. Meanwhile the reduction of some of the images (such as the piano) to their primary features, followed by the radical transformation of others (such as the piano with stairs), derives in part from her corresponding interest in the work of Richard Artschwager (see p. 22).

The conditions in which Fritsch's work was presented became an increasingly important issue for the artist as the 1980s progressed. In 1984 she fabricated a cylindrical metal frame with five circular glass shelves on which she set several of her early works, including the car and trailer, the mill, and a daffodil-yellow cast of a kitsch Madonna that she would later enlarge to human scale for an outdoor sculpture exhibition in Münster. The same year she made *Display Stand*, Fritsch also created *Eight Tables with Eight Objects*, an octagonal sectional table arranged with a bowl, a vase, paired boiling pots, and other objects.

It is tempting to compare Fritsch's antiseptic accumulations with Jeff Koons's Plexiglas-encased vacuum cleaners (see p. 76), or her simulacra of gift-store or religious items with his taste for similar mass-market goods, but she sees things differently. "Koons is much more interested in socially related criticism for provocation. For me it's not about the cynicism of the '80s, the twists in consumer society. What I want is to create a completely opposite constructive picture." Indeed the entrancing affect of Fritsch's sculpture owes less to commercial conditioning than to the curious combination of their stereotypical (as in the case of the household objects) or archetypical (as in that of the gigantic rats she recently made) generality of shape and their absolute specificity as individual pieces. "Of primary importance to Fritsch in all of her works," writes the curator of her 1997 retrospective, Gary Garrels, "is finding or creating a borderline of perception between the physicality or materiality of an object and its existence as an image in the mind, that is as something essential and pictorial."

Black Table with Table Ware (1985) illustrates this point. Initially the piece may strike one as nothing more than a dinner table of nondescript modern design, laid with a similarly undistinguished dinner service. The rigid symmetry of the ensemble nevertheless commands attention, as does the odd pattern on the plates and cups, depicting two identical men facing each other at an identical table, as if the setting for the picture had been cloned from the sculpture, or vice versa. (A second installation version of the sculpture required that the twins who had modeled for the picture participate by occupying their respective positions on opposite sides of the table.) And then one gradually realizes that everything that had at first seemed factory produced is in fact handmade, and imbued with the artist's extraordinary concentration.

Little by little, this apparently unexceptional amalgam assumes a hypnotic, altogether exceptional sensory intensity. In the final analysis, nothing about the work is obviously unnatural, but everything is informed by a strict aesthetic will. Here objects of use defy use, not merely because they are in a museum, but because one cannot imagine disturbing the rigid order of an entity in which each component is held in place like a compass needle caught in a magnetic field. The part-by-part materialization of a visionary fixity, the table, chairs, and china, like most all of Fritsch's sculpture, hover between the generic and the unique. Instead of provoking laughter at or critical thoughts about the uniformities of the modern age, the piece as a whole inspires wonder. As a work of art, meanwhile, it is unquestionably in a class by itself.

Katharina Fritsch. *Black Table with Table Ware*. 1985.
Wood, paint, and plastic, table: 29½" (74.9 cm) high x
39⅜" (100 cm) diameter, with chairs: 35⁷⁄₁₆" (90 cm)
high x 59¹⁄₁₆" (150 cm) diameter. Loan to The
Museum of Modern Art, New York, from
Elaine Dannheisser

Gilbert & George

Gilbert: born Italy, 1943, lives in England; George: British, born 1942

Now known only by their linked first names, the artistic collaboration of Gilbert Proesch and George Passmore is thirty years old and ongoing. Both born into provincial lower-middle-class families, the two men met for the first time at the St. Martin's School of Art in 1967. It was the heyday of "Swinging London"—of Carnaby Street fashion, British pop culture and rock music, and unprecedented social mixing and mobility in an imperial and tradition-bound nation. At St. Martin's, under the guidance of sculptor Anthony Caro, it was also the penultimate hour of high formalist art, for the most part typified by elegantly delineated and juxtaposed abstract shapes directly influenced by Caro's own Cubist-derived constructions.

Variants on or deviations from Caro's example soon made their appearance, however, and Gilbert & George's classmates were responsible for much of the best experimental work done in this vein. Barry Flanagan created and arranged fabric forms that synthesized Caro's color, Claes Oldenburg's soft sculptures, and Minimalism's modular accumulations, while Hamish Fulton took a walk—literally—and, along with Richard Long (see p. 82), developed a new art form correlating texts, photographs, drawings, and scavenged objects that documented their explorations of the natural environment.

No less radical—but in many respects avowedly anti–avant-garde—Gilbert & George looked backward to statuary for their inspiration and to Edwardian vaudeville for their style. Each playing Pygmalion to the other, they christened themselves "living sculptures" in 1970, and so became their own primary medium. Conservatively groomed and buttoned up in nondescript suits, with their faces and hands painted red, silver, or copper, the pair performed to old popular songs, or struck stiff serial poses in urban public places, scenic parks, and countryside vistas. They also advertised, recorded, and explained their activity with invitation cards, mailings, texts, booklets, drawings, and gridded photographs, all characterized by simultaneously "hip" and anachronistic mannerisms.

Whimsical reactionaries—"[We are] very right wing"—during most of the past quarter century, Gilbert & George have gone on from these generally modest and often ephemeral early projects to elaborate an increasingly large-scaled genre of retro-Pop, embodied by the hand-tinted photomontages that have occupied them since 1980.

Centered on their own dandified personae, these billboard-sized picture grids combine loud graphics, cinematic layouts, scatological sight gags, parodic references to revolutionary struggle and Socialist Realist art, frank but frequently playful homoerotic imagery (theirs is an all-male universe of comely proletarian boys idolized by primly bourgeois elders for whom the artists provide the models), religious kitsch, vestigial romanticism, and genuine longing for a decorous and well-tended England that has all but ceased to exist.

Gilbert & George's arch but ambiguously deadpan mode of address is fully evident in the photo-piece *Down to Earth* (1989). In it the two companions stand off-balance in the middle of a quaint village graveyard. But for the neon chiaroscuro in which it is bathed, this stereotypical setting could suit an English comedy of the 1960s, or an episode of the sort of period drama nowadays recycled by the BBC and *Masterpiece Theater*. Aggressively ordinary in appearance, as usual the "down to earth" everymen, Gilbert & George flank a subliminally phallic headstone. Behind them, enlarged self-portraits comically amplify their horror of ending up "down to earth," or under it. Accented by a stagy composition, garish hue, decorative floral detail, and mock expressionism, this composite image, like the ever expanding corpus to which it belongs, casts contemporary life in an uncanny and ironic light, as if Warhol's irradiated silk-screen images had been filtered through the prisms of Gustave Moreau and the Pre-Raphaelites.

Around 1900, classic modernism nourished itself on fin de siècle decadence only to turn its eyes toward the future in the years just before and after World War I. Nostalgic at the end of this century for the end of the last one, Gilbert & George break modernist taboos prohibiting aesthetic impurity, satirize the contemporary fear that a whole civilization may in fact be dying, and simultaneously evoke a true sense of loss. The overall effect is weirdly funny yet unsettling in ways that can shake one up. By burlesquing and otherwise overexposing the stylistic devices they customarily employ, thus laying them bare for all to see, Gilbert & George paradoxically assume a basic modernist stance that they seem to have shunned in every other aspect of their endeavor. Deliberately artificial, their work is never entirely frivolous. On the contrary, its artificiality is critical in intent. For if one accepts Susan Sontag's assertion that the aesthetic of camp is

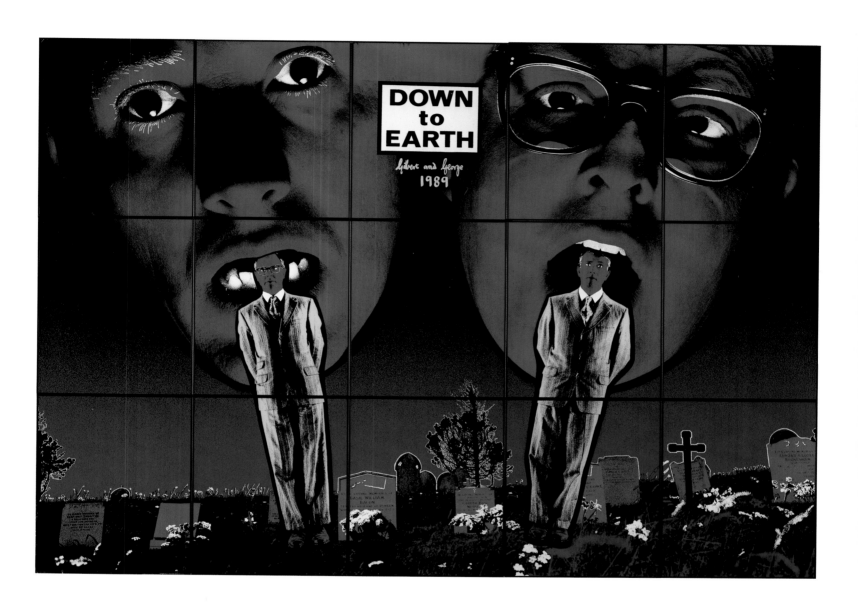

Gilbert & George. *Down to Earth*. 1989. Fifteen black and white photographs, hand colored with ink and dyes, mounted and framed, each 29½ x 25" (74.9 x 63 cm), overall: 7' 4½" x 10' 5" (224.8 x 317.5 cm). Fractional gift of Werner and Elaine Dannheisser

based on a seriousness that fails—as when heartfelt emotion becomes laughable through exaggeration—then Gilbert & George have in a sense given this process of inversion an added twist, forcing the conventions of camp to such extremes that their art betrays its underlying anxiety and so "fails" its way back to seriousness.

Robert **Gober**

American, born 1954

A work of art by Robert Gober is a "true" or "false" question for which the only adequate answer is anxious indecision, since the exquisite falsehood of the objects that provoke this response is also the purveyor of basic, usually disquieting emotional truths.

Take Gober's untitled bed piece of 1986, for example. Built of dark, heavy wood and neatly draped with clean sheets and a blanket, it is a ringer for the bed of so many American childhoods. As such, it is also a metaphor for the protective care that is, at least in theory, the deserved lot of the young and the duty of their elders to provide. Although obviously unusual in design, *Open Playpen* (1987) initially raises the same expectations of safety and domestic order. Lacking one of its four sides, however, *Open Playpen* is an ambiguous icon: does this openness destroy security or offer freedom? Do the rails that normally enclose a crib imprison infants like small animals or shield them from the dangers outside? And so back to the bed, in all its strange perfection, for is this not the place where one once lay at night listening to the noises of the house and the sounds of adult voices in other rooms, and did those noises and overheard exchanges offer comfort or instill fear? Was the bed a reassuring haven or a lonely platform at the edge of frightening realities? In this way, two images that represent the promise of undisturbed play or rest provoke thoughts of vulnerability and sleeplessness.

The ambivalence that Gober's sculptures inspire, and the richness of the fantasies they are capable of stirring in individual viewers, are a function of their extraordinary ordinariness. If that quality seems like a contradiction in terms, then its essence is not purely logical but psychological instead. The experience that Gober's work evokes is the paradoxical phenomenon labeled "the uncanny" by Sigmund Freud. The German word for it is "*unheimlich*"; sharing the same root, the term's antonym is "*heimlich*," meaning "familiar," "homey." For Freud, then, the "uncanny" is something normal that as a result of even the slightest disorientation reveals a hidden abnormality. In Freud's words, "The 'uncanny' is that class of the terrifying which leads back to something long known to us, once very familiar. . . . An uncanny experience occurs either when repressed infantile complexes have been revived by some impressions, or when the primitive beliefs we have surmounted seem once more to be confirmed." In short, the uncanny makes itself known to us when long-forgotten fears resurge and long-established certainties break down in a confrontation with everyday realities that have inexplicably acquired a surreal aspect or intensity.

This dynamic is at work throughout Gober's diverse output. Since his first one-man gallery exhibition, in 1984, that output has included not only sculpture but paintings (which now exist only in slide form and are shown in sequence as a single piece), drawings, photographs, unconventional prints (including wallpaper, upholstery fabrics, and altered newspapers), and large-scale installations. The themes Gober treats frequently overlap, creating an integrated sign system that is internally coherent but largely hermetic.

Cleanliness, for instance, is a recurrent trope in a number of otherwise formally dissimilar works. The first sculptures to gain the artist widespread attention, in 1987, were a group of scrub sinks, though like everything else Gober has done they were not the real thing but laboriously handmade facsimiles of these utilitarian basins. The untitled sink piece of 1985 in this collection is prototypical of the series, which in later incarnations took on increasingly eccentric characteristics as Gober transformed the works into nearly abstract wall reliefs not unlike those of Richard Artschwager (see p. 22) while also satirizing the modular elaborations of Carl Andre, Donald Judd, and Richard Serra (see pp. 20 and 118). (Where Judd, Serra, and Andre relied on manufacturing materials and processes, and by association lent their work a look of tough impersonality, Gober's re-creations of factory products have a readily apparent, at times almost tender sense of touch.) The 1985 piece is emphatically plain by comparison to these larger sink sculptures; stripped of its drain pipe and fixtures, it is an immaculate vessel incapable of containing anything, and through which nothing passes. *Cat Litter* (1989) is a multiple that was initially shown as part of an installation, the centerpiece of which was a free-standing but unoccupied wedding

dress, similar to the one Gober donned for his portrait *Untitled* (1992). This photograph was itself printed on the society pages of simulacra of a newspaper that Gober stacked, bound, and left against the wall of another environmental piece—this time featuring sinks with incessantly running water—that he created for the Dia Center for the Arts, New York, in 1992.

If the bed and the playpen disturb the viewer by stirring sublimated fears of insecurity, in its own way each of the three images just mentioned—the sink, the cat litter, and the photograph—summon thoughts of uncleanness by referring to the acts of washing and of absorbing waste, or to the codes of prenuptial virginity. The latter may also be correlated with the collaborative photograph taken by Gober and Christopher Wool in which a dress is seen hanging on an anthropomorphic tree, in the midst of a thicket of trees similar to the one Gober used as the motif for the wallpaper he showed in a 1991 exhibition in Paris. (The *Untitled* of 1991, the wax leg with candles, was a dominant presence in that

exhibition.) Finally, in tracing such correspondences one must not overlook similarities between the bars in *Prison Window* (1992), with its tantalizingly remote glimpse of sunlit freedom, and the rails in *Open Playpen*.

Gober's insistent toying with illusion and reality, the authentic and the fake, has much art history behind it. Certainly, his sinks—and for variety he also reproduced urinals—refer back to the infamous store-bought urinal that Marcel Duchamp submitted as a sculpture to a 1917 exhibition in New York. By the same token, Gober's sometimes oversized replicas of cat-litter bags, newspapers, cigars, breakfast cereal boxes, and sticks of butter recall the out-of-whack verisimilitude of the Belgian Surrealist René Magritte. For their parts, the hirsute child's shoe *Untitled* (1992) reminds one of the ant-infested hand in Luis Buñuel and Salvador Dalí's 1929 film *Un Chien andalou*, while the legs unaccountably intruding through the wall in *Untitled* (1989–90) and *Untitled* (1991) transform the elegant arm-bearing candelabra of Jean Cocteau's *La Belle et la bête* (1946) into rough contemporary equivalents.

Robert Gober. *Open Playpen*. (1987.) Enamel paint on wood, 25½ x 35¾ x 35¾" (64.8 x 90.8 x 90.8 cm). Fractional gift of Werner and Elaine Dannheisser

Robert Gober. *Untitled*. 1992. Toned gelatin-silver print, 16¾ x 12⅝" (42.5 x 32.1 cm) sight, 24 x 19¾" (61 x 48.3 cm) framed. Gift of Werner and Elaine Dannheisser

Robert Gober and **Christopher Wool**. *Untitled*. 1988.
Gelatin-silver print, 13⅛ x 10⅛" (33.3 x 25.7 cm) sight,
20 x 16" (50.8 x 40.6 cm) framed. Fractional gift of
Werner and Elaine Dannheisser

By this late date in the modernist era, such precedents are common property. What counts is the uses to which an artist puts them. In this respect Gober joins a number of his contemporaries— Matthew Barney and Cindy Sherman among them (see pp. 24 and 122)— in extending the Surrealist attack on common sense into a detailed examination of the binary opposition between the natural and the unnatural. Indeed, Gober's obsessive stylistic naturalism is the necessary foil to his critical assault on the conventional wisdom regarding "unnatural" desires or identities.

The child in bed thinks the unthinkable and dreams the forbidden. As an infant in its crib, the same child acted out primordial versions of these fantasies. The adult, on the other hand, must suppress them, for they violate the norm— but as Freud was quick to point out, they may erupt at any moment in some mundane guise. Gober's wax legs represent just such an occurrence. But the hold they exert over those who encounter them by chance varies with the taste of the viewer, just as the measure of disturbance they cause varies with the level of that viewer's sublimation.

With its fleshy waxen skin, actual human hair, and plain pants leg, sock, and oxford shoe, *Untitled* (1989–90) has a slightly macabre aspect, and, given the fact that it is literally underfoot, a slightly aggressive one too. For some, moreover, it may also have a distinct erotic appeal, inasmuch as it focuses on a narrow band of the body where men routinely and unself-consciously show their nakedness. *Untitled* (1991) complicates this basic set of variables considerably: here a man's full lower body lies prone, his buttocks clothed but on display along with his wax extremities, from which rise, with the same abruptness with which he seems to grow out of the wall, phallic candles that if lit would presumably consume him. The first of these two pieces is essentially fetishistic, the second is a compound symbol of sexual longing and mortality.

Patently homoerotic, like the self-portrait in wedding drag, the leg sculptures upset the enforced categories of "normal" and "abnormal" by appealing directly to the senses in ways that ordinary inhibitions fail to prevent. It is virtually impossible to resist the visual and tactile intensity of Gober's objects, even when one knows that engagement with them— and enjoyment of them— threatens to blur socially enforced distinctions separating "acceptable" from "forbidden" pleasures. Gober's point is not simply to shock or seduce people into new aesthetic experiences but to open up possibilities for imagining the world from an entirely different perspective. He regards his "otherness" not as an anomaly but as a perfectly valid vantage point, and he questions what he sees from that position. Thus the wedding picture is not just an avant-garde gag; it is a wittily romantic commentary on the lack of any male rite of passage comparable to female rituals of the bride. In much the same way, the bed, the crib, the high barred window, and the wax shoe beckon with nostalgia or archetypal magnetism even as they alter our relation to the commonplace things to which they bear the closest resemblance.

Gober's conundrums are the stuff of waking reverie, and of everyday surprise at things as they seem to others. Suppose, they say, all around us was the same as usual, except. . . . With each new body of work Gober makes, those exceptions grow, and their fascination deepens.

Robert Gober. *Prison Window*. 1992. Plywood, forged
steel, plaster, synthetic polymer paint, and electric light
bulbs, overall: 48 x 53 x 36" (121.9 x 134.6 x 91.4 cm).
Edition: 1/5. Gift of Werner and Elaine Dannheisser

Robert Gober. *Untitled*. (1985.) Plaster, wood, steel,
wire lath, and enamel paint, 28¾ x 25 x 20½"
(73 x 63.5 x 52.1 cm). Fractional gift of Werner and
Elaine Dannheisser

Robert Gober. *Untitled*. (1986.) Enamel paint on wood, cotton, wool, and down, 36½ x 43 x 78⅜" (92.7 x 109.2 x 194 cm). Fractional gift of Werner and Elaine Dannheisser

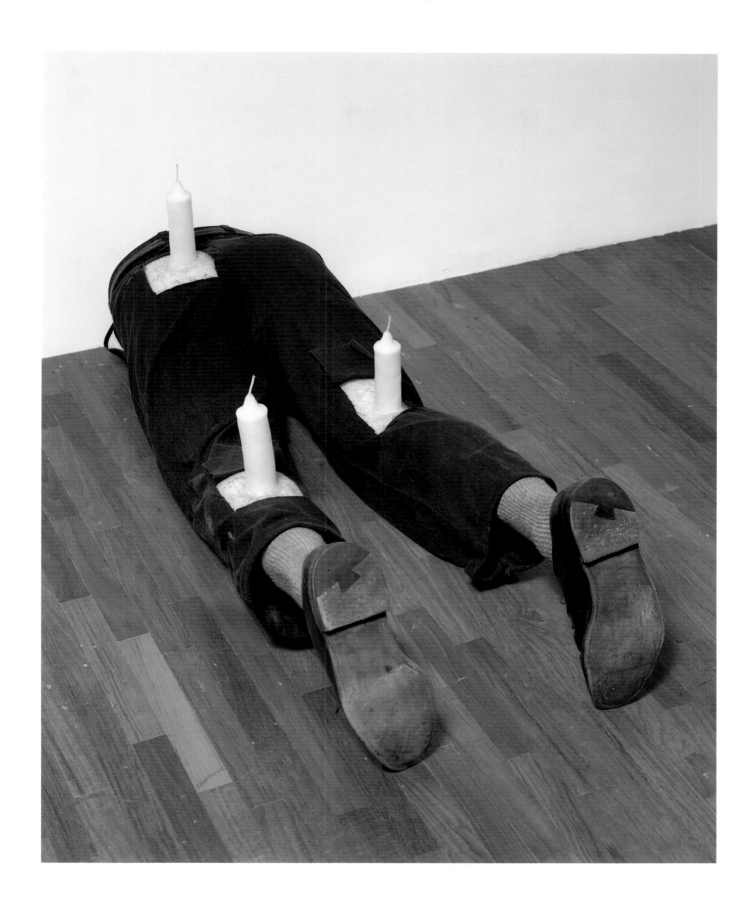

Robert Gober. *Untitled*. (1991.) Wax, fabric,
leather, human hair, and wood, 13¼ x 16½ x 46⅛"
(33.6 x 41.9 x 117.2 cm). Fractional gift of Werner
and Elaine Dannheisser

Robert Gober. *Cat Litter*. 1989. Plaster, ink, and latex paint, 17 x 8 x 5" (43.2 x 20.3 x 12.7 cm). Edition: 2/7. Gift of Werner and Elaine Dannheisser

Robert Gober. *Untitled*. (1989–90.) Wax, cotton,
leather, human hair, and wood, $11\frac{3}{8}$ x $7\frac{3}{4}$ x 20"
(28.9 x 19.7 x 50.8 cm). Gift of Werner and
Elaine Dannheisser

Felix **Gonzalez-Torres**

American, born Cuba, 1957—1996

On the 16th of May 1992 an image turned up on twenty-four billboards around Manhattan, Brooklyn, Queens, and the Bronx. The blowup of a light, grainy photograph, it showed the upper half of a bed covered with wrinkled white sheets, and topped by two pillows still bearing the imprint of the heads that had laid upon them. Startling by its reticence and delicacy amidst the usual run of advertising, the enlarged picture was also surprising because, as time passed, it became evident that it was not advertising at all. When it first appeared, the transfixing bareness of the layout seemed to be waiting for some text to be dropped in, as is now customary in suspense-based campaigns where a brand's logo — the Folger's mountain, say, or the piratical captain of Morgan's rum — is emblazoned across cities before its name or slogan is revealed. But while people on their way around town waited for some label or pitch to be added to the image of the bed, nothing happened.

Or, rather, something did happen, but it depended on them rather than on the billboard's unidentified source. As interviews with passersby attested, once the picture had taken hold in their minds they began to supply their own explanations for it, or at least their own questions: "Whose bed is that?" "What kind of couple has shared it?" "What made them leave?" "What's this private scene doing in a public place?" So doing, viewers supplied their own content for the anomalous but oddly familiar vignette. Where nothing was said, they were free to project their own experiences or fantasies on this unspecified and vastly enlarged domestic situation, and the nature of those experiences and fantasies varied as greatly as did the considerable portion of the huge metropolitan population that stopped for a second, or longer, to wonder at the sight above them.

Those questions and that sort of speculative response were exactly what the artist, Felix Gonzalez-Torres, had wanted to provoke; they were the content of the piece as much as his motives for making it were. Organized by Anne Umland for the "Projects" series at The Museum of Modern Art, this landmark outdoor exhibition was typical of Gonzalez-Torres's quiet infiltrations of homes, galleries, museums, and public spaces. Politically oriented and politically adroit, he tackled the thorniest issues of public policy and socially committed aesthetics with an imaginativeness, intellectual rigor, and rhetorical self-restraint unmatched in

his generation. Personally implicated in many of the issues he raised — especially that of AIDS, from which he was to die — Gonzalez-Torres never indulged in special pleading but, rather, fashioned the subtlest, most seductive links between those intimately aware of the inequities, threats, and desires toward which he pointed and those untouched by or as yet unconscious of them. While much of the activist art made in the 1980s and '90s aggressively challenged the ideas and habits of its audience (too often by overly obvious means), that of Gonzalez-Torres sought involvement before argument — not because the artist wished to soften the bitter truths he had to tell, or hoped to create a false sense of community where none existed, but rather in order to get past the public's defenses, deeper under their skins, and closer to the contradictory attitudes and aspirations that shape American consciousness.

Gonzalez-Torres's career spanned a brief but extraordinarily focused and productive eleven years between his inaugural one-person exhibition in 1985 and his death in 1996, one year after a retrospective at New York's Solomon R. Guggenheim Museum. Born in Cuba in 1957, he emigrated to the United States in 1968. In college he studied literature, especially poetry; in art school he majored in photography. These two concentrations established the poles around which his work would develop: text and image, original or appropriated, together or separately, as with the wordless "Projects" billboard and the all-black, all-text chronological billboard of 1989 commemorating important events in gay history, the first such public work by the artist. Between these two extremes — which encompassed the critical use of verbal and visual representation as well as their sensual, pleasurable powers of evocation — Gonzalez-Torres explored sculpture, installation, printmaking, and other mediums and formats.

The work in this collection includes examples of virtually all aspects of his activity, including the 1992 "Projects" billboard. Blatant sexual imagery and subliminal erotic hints are staples of advertising, but the advertising format has rarely if ever been used to allude to the tender, mundane intimacies of people's lives in so open a manner as in this enlarged picture of a bed. The most disturbing aspect of the photograph is its lack of sensationalism, its completely matter-of-fact recognition of all the possible relations that go

on behind closed doors. Gonzalez-Torres's discretion is anything but that of the closet, however. Quite the contrary: by leaving the bed empty, he invites any and all couples to see themselves nestled in its comforting hollows. By the same token, however, everyone who imagines themselves and a lover in that setting implicitly admits that others with other lovers in mind — gay or straight, of different classes and different backgrounds — have equal claim to imagining the same thing.

The bed's beckoning neutrality is crucial to its democratically erotic attraction. This said, as a member of a minority within a minority — that is, as an openly gay man of Hispanic heritage — Gonzalez-Torres had no illusions about the unstated costs of crudely adhering to the principal of the greatest good for the greatest number. *"Untitled"* (*Supreme Majority*) (1991) is an oblique rebuke to simple-minded populism of the kind that has flourished in recent years, especially on the far right. The seven slender cones that

Felix Gonzalez-Torres. *"Untitled" (USA Today)*. (1990.) Red-, silver-, and blue-cellophane-wrapped candies, endlessly replenished supply, ideal weight 300 lbs., dimensions variable. Gift of Werner and Elaine Dannheisser

make up the piece may at first glance strike one as perfectly abstract, but with or without the aid of the title they soon enough reveal their identity as comically pointy-headed dunce caps, while, seen against a blank wall, also doubling for the spiked peaks and valleys of opinion-poll charts or business-cycle graphs. More specifically, the caps allude to the seven Supreme Court justices appointed by the Republican administrations of Ronald Reagan and George Bush.

The references to Minimalism in this piece are intentional: in many respects, Gonzalez-Torres's work is as much a comment on the purity and permanence of Minimal art as it is on political or social realities. In the turmoil of the 1960s, Carl Andre, Richard Serra (see pp. 20 and 118), and others saw their work as explicitly antibourgeois in scale, methods, and materials and as implicitly in accord with the revolutionary ferment of the time, as well as with the heroic strain in early modernism. Gonzalez-Torres, coming into his own in the conservative 1990s, looked back on such claims sympathetically but without sentimental indulgence. Big, expensively fabricated abstractions in industrial metals no longer conveyed the liberating jolt they once had; taste had caught up with them, as had the economic realities of their production, not to mention the polemical excesses committed on their behalf. Gonzalez-Torres's choices of paper over steel, candy over machined modules, and subversive charm over righteous confrontation or solemn protest are reflections of this difference in generational perspective.

"Untitled" (1990), for example, combines the basic vocabulary of Minimalist box constructions with the art-for-everybody logic of Sol LeWitt's cheapest multiples and the mournful ephemerality of much post-Minimalist process and environmental art. Arranged in tiers, reams of paper with a wide blue band printed on them constitute three differently proportioned geometric stacks of arresting sculptural authority. Given Gonzalez-Torres's instruction that viewers be allowed to take a sheet of paper away with them if they wish, this classic Minimalist presence rapidly gives way to an unpredictably piecemeal disappearing act, followed by a total aesthetic absence that lasts until the stacks have been reconstituted with new paper. *"Untitled"* (*USA Today*) (1990) waxes and wanes under the same stipulation. Like *"Untitled"* (*Supreme Majority*), it questions thoughtless patriotism — the candies of which it is composed are wrapped in flag-waving red, silver (like white on a sugar high), and blue, while its title puns on the name of a heavily edited and packaged national newspaper — and like the perennially renewed "unlimited edition" stack, it is there for the taking. In the vicinity of works by other artists, these pieces not only stand apart in their barbed user-friendliness, they upset the normal "look-but-don't-touch" rules of the museum or gallery and tacitly criticize the high value that the market attaches to unique, collectible objects or images.

For Gonzalez-Torres, personal life was always a political matter, and vice versa. He did not mean this in any vague or theoretical way, nor did he aim to reduce the one to the other; instead he recognized, and wanted others to recognize, the degree to which private reality is affected by political contingencies. The timeline pieces he made therefore intermingle dates, names, and buzzwords signifying major world or national events with whimsical references to decidedly minor (but not culturally insignificant) TV shows, music styles, media personalities, fashions, and other "factoids" of a similar order. *"Untitled"* (*Portrait of Elaine Dannheisser*) (1993), the text that appears on the cover of this book, is one among several word portraits he conceived in the same spirit. Usually painted in a band and in a specified typeface — Trump Medieval bold italic — at the top of the walls around a room, these fragmentary synopses of the "life and times" of their subjects resonate with memories for anyone who sees them while also making guesswork out of altogether private details, leading to the sort of self-substitution that occurred with the billboard bed. "I remember that," is the reaction to the public information; "I wonder what that's about, but I recall where I was," might be the response to the more obscure chronological notations.

The realization that history is measured in finite existences becomes intensely poignant to the viewer of the twin clocks of *"Untitled"* (*Perfect Lovers*) (1991). If absolute parity governed the affections and determined life's duration, then lovers would live and die on the same schedule. They do not. For a generation of gay men decimated by AIDS, the premature separation of partners has been a daily occurrence. It happened to Gonzalez-Torres, whose companion, Ross Laycock, was stricken with the disease not long before this piece was made. Against this background, the temporal symmetry of the two clocks is both wrenching — we know that time is running faster on one side than on the other — and elegiac: mechanically synchronized, the clocks will carry on for a provisional eternity after the deaths of both the lovers, as indeed they have since the artist's own death, in 1996.

Imagine that these two clocks were over the bed in the billboard, and then imagine once again putting oneself in the picture. Creating situations that encouraged perfect strangers to occupy the place of his "perfect lovers" was the essential gambit of Gonzalez-Torres's art. He played it many ways, but the purpose was always the same: to help people to think calmly for themselves about things that matter in a world increasingly geared toward cajoling or frightening them into obsessing about things that don't.

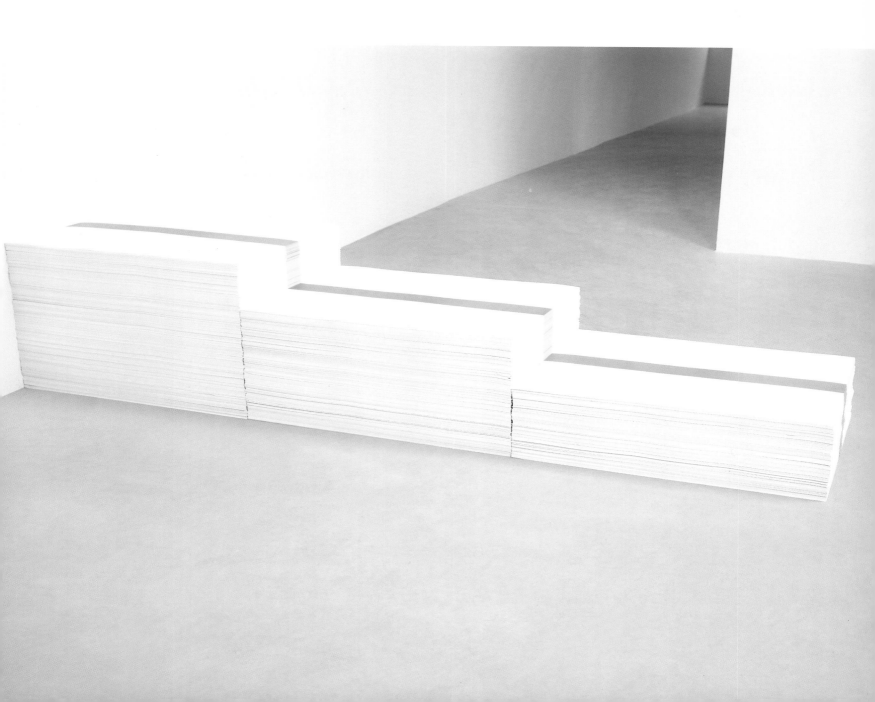

Felix Gonzalez-Torres. *"Untitled"*. 1990. Three stacks of photolithographs, endlessly replenished copies, printed in color, at ideal heights of 17", 12", and 8". Sheets: each 29 x 23" (73.7 x 58.4 cm). Installation overall: 17 x 23 x 87" (43.2 x 58.4 x 221 cm). Fractional gift of Werner and Elaine Dannheisser

Elaine 1923 right eye 1948 Poland 1939 New York City apartment 1951 left eye 1949 Watergate 1974 married Werner 1953 travels in Europe 1954 Interior Design School 1960 Sputnik 1957 President Kennedy 1963 Pearl Harbor 1941 bought space on Duane Street 1981 cancer 1981 Black Monday 1987 CNN 1980 Anaïs Nin Diary 1962 started collecting emerging artists 1981 streakers 1974 Bridge games 1991 Werner 1992 Elizabeth and Victoria 1973 La Escuelita 1993

Felix Gonzalez-Torres. *"Untitled" (Supreme Majority)*. (1991.) Paper, dimensions variable, overall: c. 61 x 40 x 36" (154.9 x 100.6 x 91.4 cm). Fractional gift of Werner and Elaine Dannheisser

Felix Gonzalez-Torres. *"Untitled" (Portrait of Elaine Dannheisser)*. 1993. Paint on wall, dimensions variable. Fractional gift of Werner and Elaine Dannheisser. Shown here in the form of a birthday-party invitation printed on card, 5 x 7" (12.7 x 17.7 cm), produced by the artist

Felix Gonzalez-Torres. *"Untitled" (Perfect Lovers)*. (1991.)
Two white-framed clocks, each clock 14" in diameter,
overall: 14 x 28 x 2¾" (35.6 x 71.1 x 6.9 cm). Gift of
Werner and Elaine Dannheisser

Felix Gonzalez-Torres. *"Untitled"*. (1992.) Printed
billboard, dimensions variable. Gift of Werner
and Elaine Dannheisser

Dan Graham

American, born 1942

Dan Graham. *"Baroque" Bedroom, "Model Home," Staten Island; Motel, San Francisco.* 1967/1982. Diptych of chromogenic color prints, each 9¼ x 14" (23.5 x 35.5 cm) sight, 35¼ x 25⅞" (89.5 x 65.7 cm) framed. Gift of Werner and Elaine Dannheisser

Nowadays Dan Graham is the designer of elegant pavilions that unexpectedly crop up in places as far-flung and as dissimilar as the roof of the refurbished warehouse building that houses the Dia Center for the Arts, in downtown Manhattan, and the verdant grounds of a tourist tent-camp on an island in Japan's Inland Sea. Made of large sheets of glass (often mirrored) and framed in metal (usually polished steel), these beautifully proportioned geometric shelters epitomize the conceptual, structural, and optical "transparency" so greatly prized by high modernists. On the face of things, Graham's current work would seem to be a long way from where he started thirty years ago, as a Conceptual artist, but the continuity of his overall project is very real. *"Baroque" Bedroom, "Model Home," Staten Island; Motel, San Francisco* (1967/1982) refers us back to those beginnings thirty years ago, in the process reminding us of the fundamental redefinition of art that occurred then.

In 1964, Allan Kaprow, the inventor of Happenings and a sometime art critic, published a seminal article, "The Artist as a Man of the World," in which he challenged the old notion of the artist as an antiprofessional bohemian who, having struggled to produce his work, has little to say about it and even less to do with determining its fate once it has left the studio. By contrast, Kaprow argued, the new members of the avant-garde were probably college educated, most likely middle class, and as responsible for advancing their work through the gallery system, the press, and academic forums as they were for making it in the first place. "A man" — or woman — "of the world," the contemporary artist had a broad practical and formal education and played multiple roles in support of his or her creative vocation.

Graham is a prime, if always eccentric, example of this type. The year Kaprow's controversial article appeared, he was working as the director of a small gallery, in which capacity he learned firsthand the aesthetic limits of modernism's traditional "white cube" exhibition space. Henceforth, he decided, he would operate outside it. Between 1967 and 1969, he followed the lead of Kaprow and other artist-critics in creating a series of magazine pieces — that is, Conceptual text works in a journalistic format, combining provocative images and layouts with terse theoretical essays.

The first of these pieces, "Homes for America," dealt with suburban architecture as if it were a serial sculpture. For Graham, the modular system of house construction, with superficial decorative variations, employed by commercial builders reflected the standardizing logic of Minimalist art like a warped fun-house mirror. At the same time, the logic of Minimalism lent these mass-produced and virtually interchangeable residential units a formal rigor they otherwise lacked. Graham's gambit was an inspired imaginative leap that in some respects paralleled that of the photographers Bernd and Hilla Becher (see p. 28). Moreover, his insight brought pure modernist abstraction into dialogue with popular culture in fundamentally unprecedented ways. Five years before Robert Venturi, Denise Scott Brown, and Steven Izenour issued their postmodernist architectural polemic *Learning from Las Vegas*, Graham had glimpsed in the tacky embellishments and heterogenous stylistic borrowings of shopping centers, chain hotels, and tract housing the basis for a fundamental rethinking of the semiotic fusion of technology and taste — or, as Graham himself has said, of how "art is a social sign." Insular meeting places and/or transparent observation points in social space, the artist's glass pavilions are the abstract architectural extension of this seminal idea.

"Homes for America" incorporated *"Baroque" Bedroom, "Model Home," Staten Island*, the upper half of the work in this collection, as an illustration of a thesis of Graham's regarding the interaction between the uniform skeleton and the patterned skin of contemporary architecture in its most widely practiced versions. *Motel, San Francisco* (1982), the bottom half of the present work, drives the lesson home. Above, one sees the debased splendor of the "Baroque" bedroom of a split-level-type house — the sterile symmetry of the room's moldings, central mirror, flanking chandeliers, segmented headboard, and paired throw pillows. Below, comparably programmatic tiers of squared-off red walls interrupted by windows and bays — which echo the shape of the bedstead in the upper photograph — are seamed by scalloped balconies. On the surface, these spaces — one interior, the other exterior — have a joyless flair; beneath that surface they are numbingly mechanical.

In Graham's montage, the critical radicality of the 1960s runs head-on into the bedrock conservatism of Middle America and its production managers. In the cookie-cutter infrastructures of suburbia and the strip, modernism's chickens — which had once appeared to be eagles — have

Top: "Carmine" Bedroom, "model Home", Staten Island, N.Y. Bottom: Model, San Francisco 1992 Dan Graham
1967

come home to roost. Yet Graham is not, essentially, a pessimist. The environments he shows us may be alienating, but they are not alien; on the contrary, they seem very familiar, so much so that it is hard to resist identifying with them to some degree, or delighting in their pretensions, despite the chill that envelops them. Contemporary art's love-hate relationship to popular culture is conflated in Graham's work with a complementary love-hate relationship to high art: the "good taste" of geometric abstraction is as much to blame for the way our cities and towns look as the "bad taste" retrograde decorators are. But Graham's purpose has been to observe rather than to accuse. Using selective comparisons to examine the complex fusions of supposedly incompatible aesthetic systems, he helped set in motion a shift away from artmaking as a search for "pure" form toward artmaking as a method for analyzing the formal impurities and social contradictions at work in the everyday world we inhabit.

Andreas **Gursky**

German, born 1955

Two photographs: one depicts a New Year's Day swim for which urban dwellers have descended on the desolate banks of their local river; the other shows people scattered in and around a pool, sunning themselves singly, in pairs, and in larger clusters. The subject of these two images — bathers — could not be more traditional. The ambience of the context they inhabit is thoroughly contemporary, however, as is the crisp, impassive style with which the photographer Andreas Gursky has recorded them.

There are other interesting points of comparison and contrast between these two images. To the extent that Gursky's art is essentially descriptive, verbal inventory of his photographs is worthwhile insofar as it names the things he saw and that he wants us to see in specific relation to one another.

In the first picture, *Neujahrsschwimmer* (New Year's Day swimmers, 1988), the city lies in the background, an even line of squared-off and gridded-out buildings broken here by what appears to be a large residential block, there by a church steeple. Landmarks from two distinct eras in an otherwise nondescript vista, they sit on the flat terrain, the more modern of them rating as a skyscraper only to the extent that the low and diffuse cloud cover has nearly come down to meet it. In the foreground, untouched landscape intrudes in the form of an irregularly shaped spit of stony beach. Against the horizon of postwar Germany — that is, of a bombed-out Germany hastily rebuilt with uninspiring new structures — the heartier burghers of the town gather to celebrate their communion with nature.

In the second image, *Schwimmbad Ratingen* (Ratingen swimming pool, 1987), the geometry of modernity occupies the foreground, behind which spreads a lawn surrounded by a well-tended stand of trees. Everything rational and inorganic in this recreational area's design — the row of benches, the diving-board tower, the dark tile border circumscribing the angular pool — is set off by the warm green of the grass and foliage and the hedgelike trees. Once again, contemporary Europe is seen abruptly juxtaposed with the past, represented here by the old-fashioned park. The public amusements of the working and middle classes that the Impressionists and Post-Impressionists took note of — think of Seurat's *Sunday Afternoon on the Island of La Grande Jatte* (1884–86), or his *Bathers at Asnières* (1883–84), and their exceedingly formal portrayal of leisure without relaxation —

become, in Gursky's optic, a truly mass affair, but remain a markedly civil one.

And then there are people, who in Gursky's pictures tend to swarm across the bird's-eye-view settings he prefers, or scuttle into their more obscure corners only to be discovered by the viewer's scanning and probing eye. This sense of motion is, of course, illusory: rather than capturing an action, the camera stops it. But where some photographers have exploited that illusion — attempting to seize an unfolding event by zeroing in and clicking the shutter so that the object of their interest is caught between one state of repose or being and the next — Gursky steps far back, so that individual gestures become imperceptible. Thus, after one has registered the visual density of his pictures as a kind of panoramic animation, the essentially static quality of these tableaux takes hold, and they come to resemble scenes created out of finely crafted miniature-railroad kits, as if modern life were mimicking the modeler's art.

The technical precision Gursky brings to his work reinforces this ambiguity. Among the most gifted younger students of Bernd and Hilla Becher, Gursky has followed their lead in dedicating himself to the dispassionate depiction of apparently mundane places and things. Yet by choosing color over black and white photography, he has departed from the Bechers' example and introduced an element that for all its realistic nuance ends up reading as hyperreal, in the same way that the most naturalistic cinematic color may outshine the world we see outside the theater. Combining a physically remote omniscience with an acute attention to the smallest bit of photographic information the lens can take in — the cast of water under a dull sky, the posture of a lounging man — Gursky's prosaic scenes acquire a strange and beautiful aura, one prototypical of a still-in-progress late-twentieth-century recodification of the nineteenth-century picturesque.

Andreas Gursky. *Schwimmbad Ratingen* (Ratingen swimming pool). 1987. Chromogenic color print, 19¹/₁₆ x 23⅜" (48.4 x 59.4 cm) sight, 28½ x 33¾ x ⅞" (72.4 x 85.7 x 2.2 cm) framed. Gift of Werner and Elaine Dannheisser

Andreas Gursky. *Neujahrsschwimmer* (New Year's Day swimmers). 1988. Chromogenic color print, 22¹³/₁₆ x 30⁹/₁₆" (57.9 x 77.6 cm) sight, 34 x 40½ x 1" (86.4 x 102.8 x 2.5 cm) framed. Gift of Werner and Elaine Dannheisser

Georg **Herold**

German, born 1947

"Nonsense is better than irony. What we get dished up to us everyday is nonsense anyway, so it's nice to oppose it with something that will meet with complete incomprehension. Once you learn to live with absurdity, it's the things you used to think were normal that seem absurd."

The distinction made here by the artist Georg Herold is an important one for art in this century. "Irony," as defined by the *Oxford English Dictionary*, is "a figure of speech in which the intended meaning is the opposite of that expressed by the words used; usually taking the form of sarcasm or ridicule." Irony is, to that extent, an offensive weapon, or a kind of mental judo in which the force of an idea is turned against itself. In the visual arts, Marcel Duchamp is of course the master ironist of our time, and as a classically educated Frenchman he fully agreed with a maxim of his eighteenth-century antecedent La Rochefoucauld: "Ridicule kills."

The product of a postwar Germany scarred by the past and rent by ideological stresses, Herold had plenty of reason to challenge inherited orthodoxy but no taste for metaphorical murder. Instead he has preferred to tease authority with an elegantly offhand silliness that taps into the intrinsic silliness of things routinely regarded with great seriousness. In the often solemn and high-stakes game of art, he is the voluntary joker in the deck.

Born in 1947 in Gena, in the Soviet-occupied zone of East Germany, Herold attempted to make his way to the West in 1973, but was arrested and jailed by East German police. Eventually released and allowed to emigrate, he made his first stop in Munich, where he studied between 1974 and 1976. From there he went to Hamburg, where he became part of a circle of contemporaries that included Albert Oehlen and the late Martin Kippenberger. All three fell under the tutelage of Sigmar Polke (Herold being Polke's student from 1977 to 1981), whose perverse intelligence triggered varied responses in them, and each in his own way pushed the older artist's madcap approach to new extremes (see p. 104). Oehlen painted burlesque versions of Nazi symbols and modernist styles; Kippenberger plumbed the depths of graphic vulgarity in prints, posters, paintings, sculptures, and performances, while reminding those inclined to underestimate him that "you can't play stupid if you are stupid." Herold for his part turned to objectmaking, and away from painting, Polke's primary medium.

Herold's favorite materials have been lath, brick, nylon stockings, buttons, wire, cement, cinder block, duct tape, and caviar. Basically neutral, these substances have little value until something is made of them, and their nature prohibits conventional aesthetic refinement. Caviar is the obvious exception: for years it was the luxury that the communist East sold to the capitalist West for hard currency. With these dangling associations in mind, Herold has used fish eggs suspended in an acrylic binder to make pseudo-paintings that bear an obvious and amusing resemblance to Polke's mineral-strewn and resin-soaked metaphysical abstractions of recent years. Attaching bricks to loosely stretched canvas, causing the linen to belly and sag, he has likewise satirized the heavily encrusted and object-laden tableaux of Anselm Kiefer, without referring to them explicitly.

Such puckish correspondences are characteristic of Herold's humor. They appear in his lath and scrap lumber constructions as indirect allusions to classic Soviet Constructivism, for example in a 1991 installation consisting of 100 wooden battens stacked on sawhorses labeled "100 Years of May 1"—May Day, of course, being the traditional day to celebrate left-wing causes and, more particularly given Herold's background, communist power. To be sure, this piece is blatantly ironical, but it is at most a glancing blow at earnest engagement; Herold eschews the kind of systematic irony that would make him a socially committed artist in reverse. "Political art is a coquetry of the artist who needs an alibi and a moral justification," Herold has explained. "Naturally, in a certain way, I do the same, but I coquette consciously with politics by making jokes."

For the rest, Herold's art holds true to his faith in nonsense and the salutary disorientation that results from a world without absolutes. A student of mathematics before he became an artist, Herold has taken poetic license from Werner Heisenberg's famous uncertainty principle, and has dabbled in the formal logic of topology. The latter interest gave rise to a series of contorted cloth-wrapped sculptures called "*Pfannkuchentheorie*," or "Pancake Theory," the name of a set of topological permutations, and it indirectly informs another series, "*Deutschsprachiege Gipfel*" (German-speaking mountains, 1985), to which *Muttler* belongs.

Each of these twelve works is made of men's underpants stretched over a simple bent-wire armature, and each one, in

the manner of traditional sculpture, is mounted on a plinth. Underneath the series' twinkle-in-the-eye rudeness — which none too subtly directs attention to the congruity between these tented objects and the tenting bulges of half-dressed men in briefs — a more nuanced wit is at work: variations on two givens, the sculptures demonstrate the range of shapes made available to the artist by simple manipulation of surface geometries. One, named *Ägypten* (Egypt), resembles a pyramid. The word "mountain" in the title of the group as a whole (*Muttler* too is the name of a Swiss peak) suggests comic images of a mountain, while the contour, disposition, and anatomical specificity of each individual piece to varying degrees also invokes Duchamp's notorious urinal or, as he called it, "fountain." Herold's nonsense thus slyly mimics Duchamp's now venerable irony, not as academic imitation or one-upmanship but as free-spirited parody — the joke comes at no one's expense, nor is it for insiders only. It is just one of those artfully incidental epiphanies that make one laugh at nothing special and everything.

On Kawara

September 30, 1997: 23,662 days

[Note: rather than publish his date of birth, the artist prefers to give his age as the number of days he has lived at a certain moment, in this case the opening of On the Edge: Contemporary Art from the Werner and Elaine Dannheisser Collection*]*

How to tell time — and how to represent it — are among the principal problems of the modern era and of modern art. For many, being modern meant living in the present, if not seeing into the future. For others, modernity was a sliding scale of spatial and temporal awareness. Meanwhile, research into the laws of physics and the existential irregularities of time had thrown all traditional calculations into question.

Nearest to the urgent immediacy celebrated by the early moderns was the exuberant sense of speed and simultaneity found in the spinning, jumbled images of Robert Delaunay, Pablo Picasso, Georges Braque, Giacomo Balla, Umberto Boccioni, and Gino Severini. The working premise of these artists, and of the various space-and-time-fracturing styles they pioneered — Orphism, Cubism, Futurism, and so on — was the notion of depicting an object, or multiple objects, from several vantage points at once, thus condensing separate observational moments into a single pictorial event. At the other extreme was the drawn-out, even static time of the Surrealists — of Alberto Giacometti's frozen *Palace at 4 A.M.* (1932–33), or of Salvador Dalí's *Persistence of Memory* (1931), with its famous melting watches.

Scientific and philosophical speculation paralleled and sometimes provoked these aesthetic experiments. Albert Einstein's general theory of relativity posited a break in temporal continuity based on the spatial separation of two clocks set to the same hour. For his part, the French phenomenologist Henri Bergson explored the discrepancy between strict chronological time and psychological time, that is to say between the measurable fact of minutes ticking into hours, hours into days, days into months, and months into years, and the fluid experience of duration in which time assumes a wondrous elasticity, stretching out or accelerating at unpredictable intervals.

The work of On Kawara literally updates these concerns in the matter-of-fact terms of contemporary systems art. Having started out in the early 1950s making Surrealist-inspired pictures of cataclysmic domestic scenes, Kawara left his native Japan in 1959 and, after sojourns in Mexico and France, settled in New York in 1965. During his time in Paris, Kawara experimented with a variety of styles, in the course of which he began making drawings based on calendars. These works prepared the ground for the conceptual leap he made shortly after his arrival in New York, resulting in a dramatic reorientation of his art and the integral programming of his production.

On January 4, 1966, Kawara made the first of his "Today" series, of which the work in this collection, *April 24, 1990*, is an example. Each consists of a neatly hand-lettered canvas commemorating the day of its creation. The canvases are stored in specially made cardboard boxes containing pages from a local newspaper of the same day and from whatever place the peripatetic artist happened to find himself in when he made the painting. Kawara does not paint every day — in the first year of this series, he made 241 such works — nor are all his canvases identical; the background tone varies from grays to reds to blues, and the typeface changes as well.

Kawara has also devoted himself to other forms of space-and-time accounting. In the same year as he began the "Today" series he started to keep lists of his encounters, noting the name of the person with whom he had come in contact after the phrase "I MET" In 1968 he began mapping his movements with the series "I WENT," and shortly after that he took to sending daily postcards to friends with the timed and dated message "I GOT UP" These mailings were followed in 1970 by another ongoing series that said "I AM STILL ALIVE, ON KAWARA." Also in 1970 Kawara opened a ledger in which, working back from the present, he began enumerating every year from 998,031 B.C. to 1969 A.D. *One Million Years (Past)*, which eventually ran to ten volumes, is dedicated to "all those who have lived and died." *One Million Years (Future)* continues the same process from 1981 to 1,001,980 A.D., and is inscribed "For the last one."

Kawara's idiosyncratically interconnected tabulations encompass both the small routines that measure out quotidian existence and the virtual infinity of millennia succeeding millennia. At either extreme, Kawara takes care to remind us how time's passage simultaneously isolates individuals in their own reality and binds them to collective reality. This divided consciousness is explicit in *April 24, 1990*. Like every other painting of its kind, it is the work of a man sitting alone at his desk. The physical encapsulation of the time it took to make (because of the layering of paint and the necessary drying periods, completion of each tablet- or tombstonelike work takes many hours), it adds to the series as a whole while it counts down, and so subtracts from, the

On Kawara. *April 24, 1990*. 1990. Synthetic polymer paint on canvas, 18¼ x 24" (46.3 x 61 cm). The painting is accompanied by a cardboard box (below) made by the artist, containing a dated page from the *New York Times*. Fractional gift of Werner and Elaine Dannheisser

unknown remainder of its creator's days. Like every other newspaper clipping of its kind, the one accompanying this work contains stories on various topics with various datelines, representing the staggered unfolding of the news. By this pairing—which in spirit as well as juxtapositional technique resembles the time-line portraits of Felix Gonzalez-Torres (see p. 58)—Kawara demonstrates the on-again corresponding or off-again tangential alignment of his own life's span with the inexorable but often absurd march of history. Kawara's idea is simple, as is his means of expression. If one yields to them, however, the thoughts and feelings they elicit are complex and fundamental.

Anselm **Kiefer**

German, born 1945

Anselm Kiefer was born in Bavaria on March 8, 1945. The date is significant, coming a little less than two months before the fall of the Third Reich. Although an infant cannot recall the circumstances in which it makes its appearance in the world, there is no doubt that the cataclysmic events that attended Kiefer's birth have had a determining effect on his art. Indeed it is precisely because he belonged to history but was unable to remember it, while being surrounded by elders who wanted to put behind them forever a tragedy they had helped to create but had also endured, that Kiefer has dedicated his work to the recovery of the past. By chronological accident but even more so by virtue of his obsession with the moral and cultural ambiguities of his partially obscured heritage, Kiefer is perhaps Germany's quintessential "postwar" artist.

His close personal and aesthetic ties with Joseph Beuys are of paramount importance in this regard. Beuys had experienced the thrall of fascism, the terrors of combat, and the shattering of all his prewar illusions. Kiefer grew up in a Germany determined to rebuild and never look back, but also, by that token, a Germany cut off from the simultaneously vigorous and blighted roots of its national identity. As a student of Beuys's at the Düsseldorf Kunstakademie, Kiefer was actively encouraged to explore the mythic themes and historical dramas that fell under this general societal taboo.

In his early performances, installations, and books — all of them much influenced by Beuys's conceptual approach — Kiefer followed this course with a jarring irreverence. His so-called "occupations" of 1969 consisted of photographic self-portraits in various picturesque locations with his arm raised in a Nazi salute, a posture that was, at that time, illegal. Impersonating a soldier in this manner allowed him both to mock the conquering spirit of the Reich and to imagine what it might have been like to be swept away by it. Several years later he enacted Hitler's never-launched naval assault on England — code-named "Operation Sea Lion" — in a specially made bathtub resembling one that Beuys had once hung on the wall as a sculptural surrogate for his own body.

By the late 1970s, in a self-conscious revival of an old German technique linking him to the Renaissance master Albrecht Dürer by way of early modernists such as Max Beckmann and Ernst Ludwig Kirchner, Kiefer shifted his attention almost entirely away from avant-garde strategies toward woodblock printing, and then toward painting. Indeed, it was as a leader of the neo-Expressionist return to heroic-scale painting that Kiefer made his American reputation in the 1980s. For most of that decade, however, Kiefer's subjects remained emphatically and at times hermetically German, even when the bold strokes, heavily textured surfaces, and large formats of his pictures suggested to many observers a conscious affinity — and cross-generational rivalry — with Jackson Pollock and the "action painters" of the 1950s.

Ritt an die Weichsel (Ride to the Vistula, 1980) is a case in point. Although a relatively small picture in Kiefer's oeuvre, it is nonetheless dense with meanings and rich in painterly effects. The subject, which Kiefer treated in several other works of the same period, is the long-embattled frontier between Germany and Poland — of which the Vistula is the principal waterway — and more generally the uncertain meeting of Europe and the East, a subject that Beuys dealt with on many occasions, in particular his "Eurasian Staff" performance of 1966. Like Kiefer's bathtub simulacrum of "Operation Sea Lion," this painting directly refers to Hitler's aggression, in this instance his 1939 invasion of Poland.

From the somber maelstrom of painterly gestures, three distinct images emerge: on the horizon gallops a flaming horse, representing the Polish cavalry that confronted the Wehrmacht tanks in hopeless defense of their country. In the foreground are another horse and a woman's head, both invoking the legend of Brünnhilde and the stallion Grane, whom she rode to her fiery death on the pyre of her slain lover, Siegfried, precipitating the immolation of the heavens and the twilight of the Norse gods.

Appropriating these characters, and along the way invoking Richard Wagner's opera cycle *Der Ring des Nibelungen*, which elaborates their story, Kiefer simultaneously commemorates the bravery of those who opposed the Reich and resuscitates cultural symbols exploited by the Nazis and therefore widely shunned ever since. The mixed feelings expressed by Kiefer's complex metaphoric overlays are the basis of his work's potency; he knows how easily historical evil becomes entangled in mythic truth, and he knows how difficult it is to disentangle them. Given this dilemma, he offers us the knot, and paints it with the full force of his passionate ambivalence.

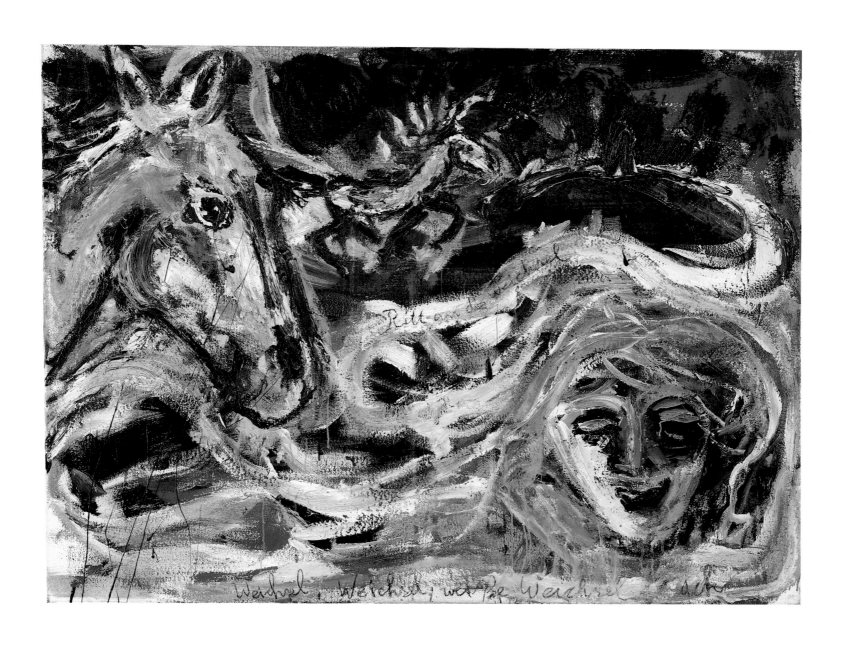

Anselm Kiefer. *Ritt an die Weichsel* (Ride to the Vistula).
(1980.) Oil on canvas, 51⅛ x 67" (129.9 x 170.1 cm).
Fractional gift of Werner and Elaine Dannheisser

Jeff **Koons**

American, born 1955

No artist among the hectically cool "postmodernists" of recent decades has flirted more openly with commercialism than Jeff Koons, nor has anyone struck so steadfastly earnest a pose in the endeavor. Unapologetically, indeed some say brazenly appropriating advertising strategies, off-the-shelf merchandise, and kitsch icons from the inventories of mass-marketers and carriage-trade purveyors, Koons — whose artistic preparation included a stint selling memberships at The Museum of Modern Art and another trading commodities on Wall Street — pursues his ambitions with missionary zeal. Self-appointed prophet of a heaven-on-earth of unashamed materialism and sexual bliss, Koons has gone Pop art one or two better, making an art of "the pitch" and "the deal," as well as art objects out of the flotsam and jetsam of consumer culture.

To the extent that Pop reflected the 1960s boom economy in its bland "liking" — Andy Warhol's term — for cheap but plentiful goods, Koons's enthusiasm for absurdly gaudy, expensive, and useless things mirrors the 1980s and 1990s bubble economy, when the middle class, which a generation before had merely been glad about its prosperity, became restlessly convinced that unlimited satisfaction of its overstimulated appetites was within reach. If Warhol, the former commercial artist turned "fine" artist, was the avatar of Pop, then Koons, the former salesman turned aesthetic product-designer, is the herald of a phantasmagorical new vulgarity. The ultimate irony of Koons's position is that he does not own up to any irony, but instead proselytizes tastelessness with the moral fervor of a social reformer. Like Warhol, whose impassive persona was an essential part of his work, Koons, the only real pretender to Warhol's throne and a patient explainer of his own inexplicably ugly but intensely desirable pictures and sculptures, never breaks character.

Producing and packaging his work in series and groups like a high-end retailer launching each year's "line," Koons has followed a simple but perverse strategy. Entitled *The New,* his one-person debut in 1980 presented an assortment of appliance-based works similar to *New Shelton Wet/Dry Double Decker* (1981), although this particular piece was not included, being first shown in a group exhibition in 1982. His second show, featuring *Three Ball 50/50 Tank* (1985) along with similar pieces and photomechanical "paintings" based on Nike sportswear ads, was called *Equilibrium.* The artist's third ensemble, in 1986, was *Luxury and Degradation,* and it concentrated on liquor ads and drinking paraphernalia, the latter cast in stainless steel and including *Baccarat Crystal Set* (1986). His fifth series, *Statuary,* centered on similar, one-to-one-scale reproductions of gift-shop sculpture, and his sixth and until then most extravagant offering, *Banality,* consisted of gigantic tchotchkes executed in polychromed wood and porcelain, of which *Pink Panther* (1988) is a prime example.

On one level Koons's humor is pleasurably sophomoric. His mating of Jayne Mansfield and the eponymous cartoon character in *Pink Panther* is a thoroughly enjoyable send-up of heterosexual rapture and celebrity romance. On another level Koons's vision is utterly sardonic. As visually alluring as it is, nothing could be more emotionally distancing than *New Shelton Wet/Dry Double Decker,* the artist's "immaculate conception" of two virginal vacuum cleaners enshrined in Plexiglas. *Three Ball 50/50 Tank,* in which three basketballs bob in a half-filled aquarium, is likewise sterile and claustrophobic, while *Baccarat Crystal Set* is as sparkling cold as anything money can buy.

Plainly not all is well in Koons's bourgeois paradise, an awareness the titles of his shows reinforce. After *The New* (an overt provocation aimed at old avant-garde ideas of artistic innovation) came *Equilibrium,* the title a pointedly ambiguous evocation of unattainable balance, the show making reference to an equally unattainable athletic prowess (and prompting comparison with Matthew Barney's weirdly utopian sport metaphors; see p. 24). *Luxury and Degradation,* with its allusion to alcohol addiction, and *Banality,* with its focus on object-lust and needy sentimentality, shifted the progression into a darker key, even as the things Koons was fabricating to represent his evolving program were becoming bigger, brighter, and more alarmingly cheerful.

Finally, it is in Koons's pursuit of technical perfection in re-creating inherently debased prototypes — his expenditure of untold labor on intrinsically worthless albeit mentally indelible forms and images, to which he assigns exorbitant value — that the essential morbidity and despair of his ostensibly "feel-good" art shows through. Banking on the built-in obsolescence of most of what contemporary industry and culture disgorge, Koons harbors the old-fashioned hope that his work, though poetically stillborn, will endure for the ages. "My objects, maybe not in a traditional sense art, last longer than you or myself. Maybe they'll die off as art, but they are equipped to outsurvive us physically."

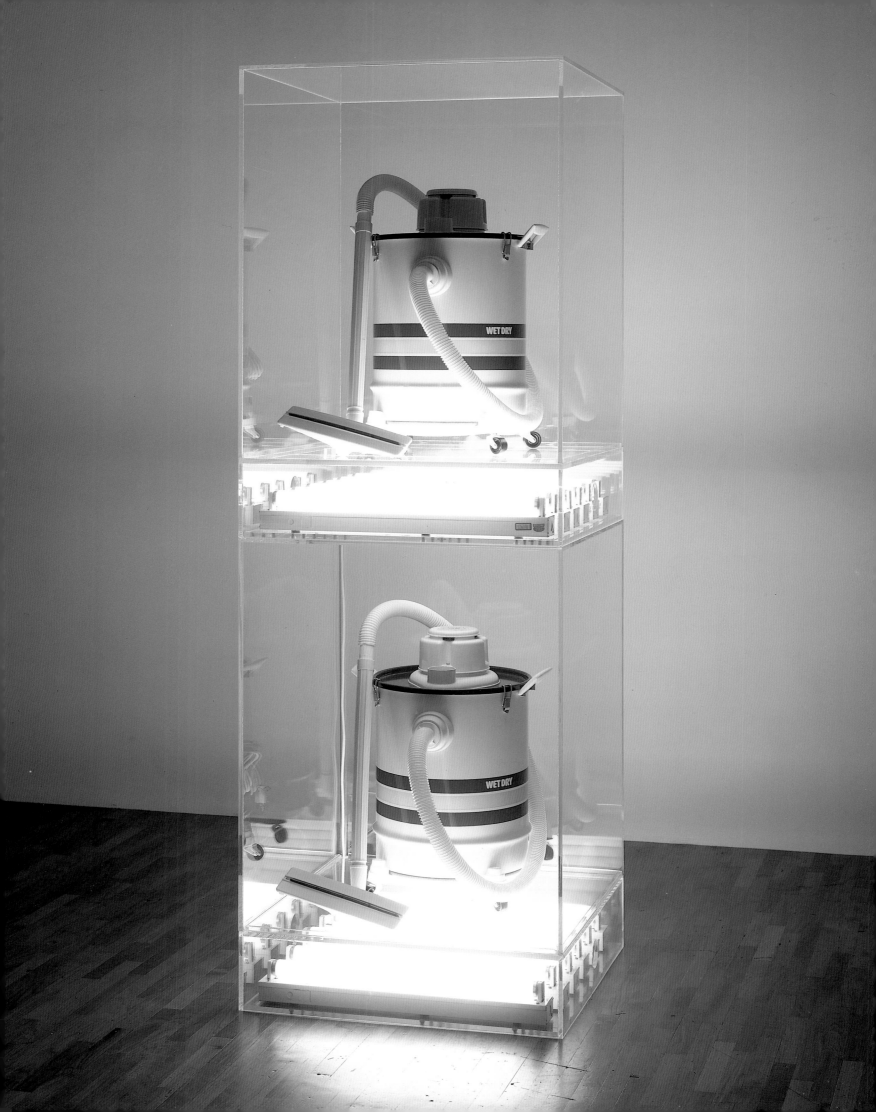

That is a harrowing prospect, but a serious intent. Bad habits and disequilibrium threaten the artist, so he makes modern-day fetishes to reverse their power. Ephemeral reality scares him, so he makes indestructible totems to things that never lived and so cannot perish. His big yes to excess is a big no to irrepressible guilt. Despite all his put-ons and superficial cynicism, Koons is at bottom a deadly serious artist — and, like the similarly haunted Warhol, a pivotal figure of his increasingly pessimistic generation.

Jeff Koons. *Baccarat Crystal Set*. (1986.) Cast stainless steel, 12¼" (31.1 cm) high x 16½" (41.7 cm) diameter. Edition: 2/3. Fractional gift of Werner and Elaine Dannheisser

Jeff Koons. *Three Ball 50/50 Tank*. 1985. Glass, painted steel, water, plastic, and three basketballs, 60⅝ x 48¾ x 13¼" (154 x 123.9 x 33.6 cm). Edition: 1/2. Fractional gift of Werner and Elaine Dannheisser

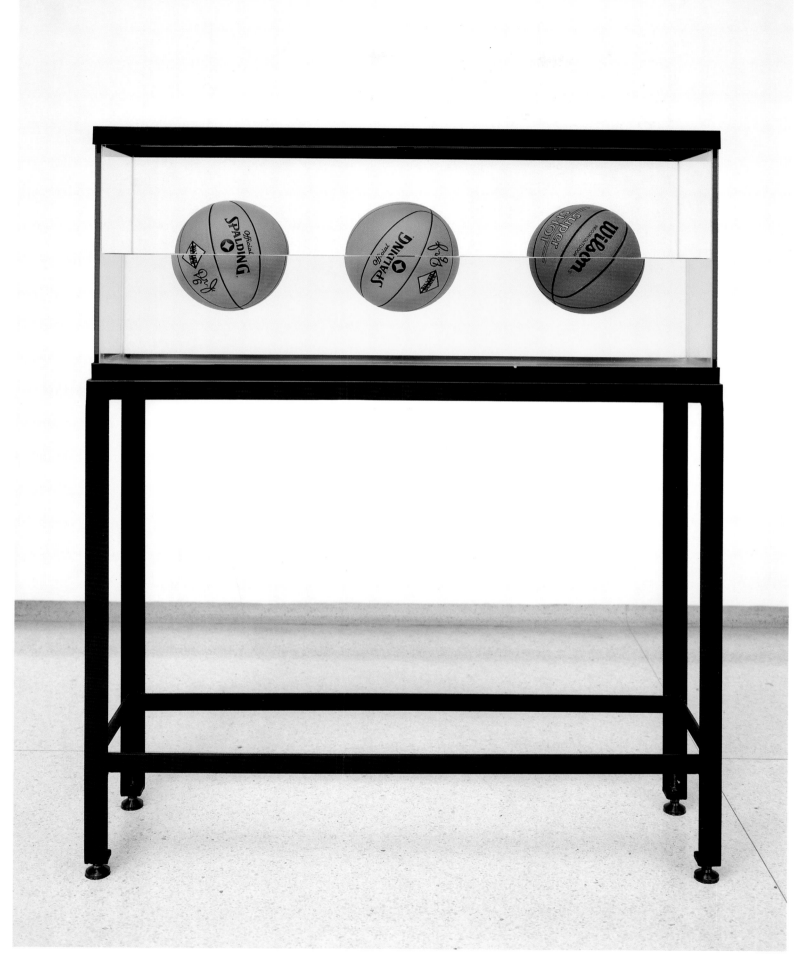

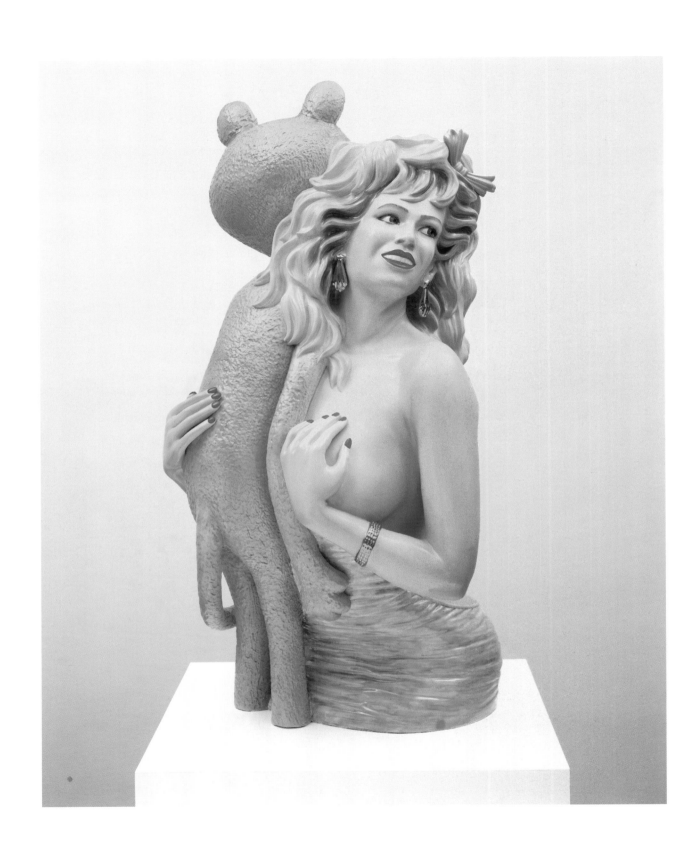

Jeff Koons. *Pink Panther*. (1988.) Porcelain, 41 x 20½ x
19" (104.1 x 52.1 x 48.2 cm). Edition: 1/3. Fractional gift
of Werner and Elaine Dannheisser

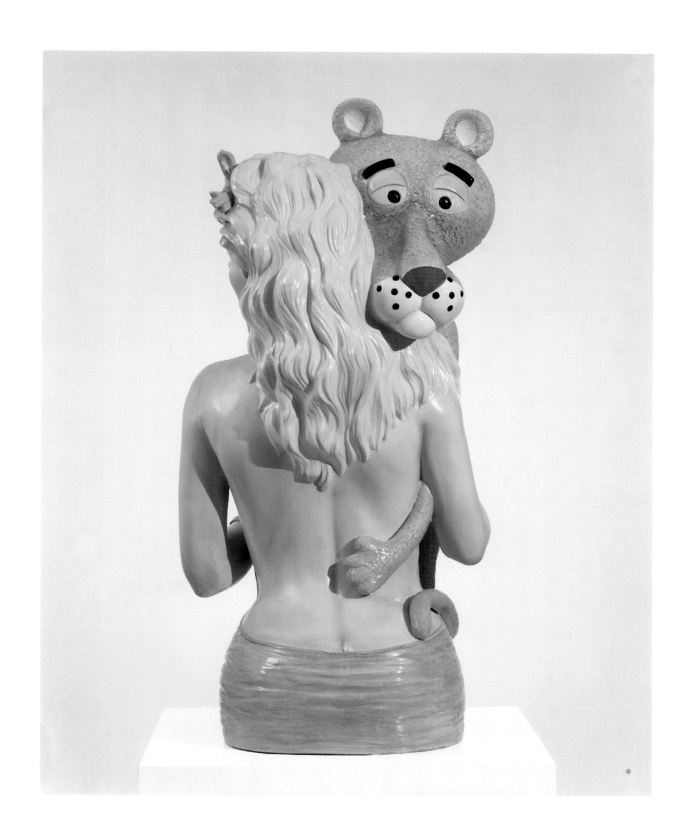

Richard **Long**

British, born 1945

In 1967 the young Englishman Richard Long took a walk and it became his art. The physical manifestation of this gesture was a snapshot documenting Long's straight-arrow course through a grassy meadow, but the conceptual leap he had made in the process was not recorded. Of course, plein air painters had been setting up their easels "on site" since at least the early nineteenth century, while sculptors had been locating objects outdoors almost as far back in history as one can go. The idea of making something *out* of nature as well as *in* it — that is, of using found situations and materials as one's medium rather than simply depicting them in another form — was new, however, or at any rate unprecedented in the contemporary form it took. Along with the loosely coordinated efforts of his contemporaries around the world, Long's experiments announced the advent of "Earth art" as a major genre.

In the background of this development was growing public awareness of the environment, and of the threats against it produced by modern industrial society. The same year Long set out on his walk, Robert Smithson began conducting guided tours of what he called the "Monuments of Passaic"; the small-town–New Jersey "monuments" in question included oil pontoons and discharging factory pipes. These two artists had other ideas in common as well, though Long's taste tended toward unblemished countryside while Smithson's homed in on the wastelands in and around cities. Anxious to explore the possibilities of artmaking "out-of-the-studio," both sought ways of representing that experience from multiple vantage points. Long's solution — closely paralleling Smithson's procedural division of his output into "site" and "nonsite" works — was to divide his activity into three categories: first, intervention on the site; second, maps, photos, or text descriptions of the site; three, the transfer of objects or materials from the site.

Kilkenny Circle (1984) is of the latter kind. A circle of rocks roughly nine feet in diameter, it conforms to one of the four basic patterns in which Long arranges the stone or wood fragments he collects during his hikes, the other three being a line, two crossed lines, and an extended rectangle. Sometimes these basic geometric configurations are created in the place where the materials were found; at other times, as in this case, the artist re-creates them within a gallery context. Outdoors, these groupings serve as markers or focal points in the otherwise virgin landscape; indoors, they strike a balance between raw physicality and platonic abstraction.

A student at St. Martin's School of Art in London when he made his discovery in 1967 — his classmates included Gilbert & George (see p. 46) — Long rejected the modified Cubist sculptural language of Anthony Caro, then the school's dominant presence, but did not entirely reject Caro's formalism. Nor was he interested in throwing off the past in the name of complete novelty. Quite the opposite: seen from the historical view, Long's approach incorporates a number of never-before-associated traditions. Linked as it plainly is to the modular floor pieces of Carl Andre (see p. 20) and Tony Cragg (see p. 40), *Kilkenny Circle* also looks back to the ancient Nazca Lines of Peru, as well as to Great Britain's own Bronze Age monuments at Stonehenge and Avebury. Meanwhile, the careful note-taking in which Long habitually indulges during his treks recalls the work of the British topographical draftsmen of the eighteenth and nineteenth centuries (John Sell Cotman, Thomas Girtin, Paul Sandby, and such), as does his equal attraction to both pastoral scenery of a domestic English variety and dramatic vistas that require his venturing abroad.

These unusual correspondences raise important aesthetic and philosophical issues, in which time is as critical as space. Two hundred years ago, for example, when the topographical landscape drawings mentioned above were first being made, much of the planet remained unknown to all but local inhabitants; but when Long now travels to remote areas, encroaching development is at his back. The poetry of the first is, with all its cultural biases taken into consideration, Edenic; the poetry of the second, with all the future's uncertainties in attendance, is ecological.

Furthermore, although Long does not mimic ancient cairns or ritual grounds, and so avoids involvement in the vexed relation between modernism and "primitive art," his sculptures evoke a world barely touched by humankind. Its temporal realities are those of seasonal growth, slow astronomical cycles, and even slower geological ones. The trace left on the earth by any individual, be it the grass Long crushed underfoot in 1967 or the rocks he has displaced and reorganized in *Kilkenny Circle*, lasts only to the extent that the materials chosen are durable; the one who chooses them is in any case totally ephemeral.

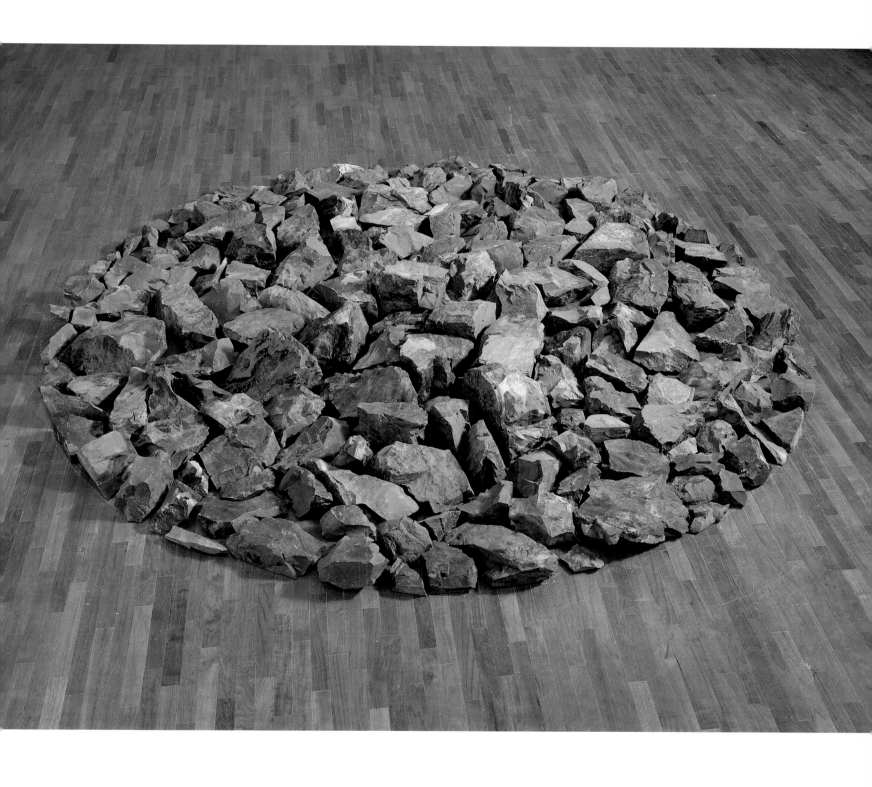

Richard Long. *Kilkenny Circle*. (1984.) 195 stones, overall diameter irregular, ranging from 99½" to 104" (252.7 to 264.2 cm). Gift of Werner and Elaine Dannheisser

From that perspective, the shards that make up *Kilkenny Circle* are symbolic fragments of the vast mineral sphere on whose surface they were once scattered, and of the solar system of which that sphere is a part. Like all his work, this sculpture is an emblematic reminder of the connection between the microcosmic units of space and time in which we make our way, and the macrocosmic expanse that opens up on every side as we pass.

Brice **Marden**

American, born 1938

Periodic announcements of the imminent "death of painting" have been a refrain of artists and critics since early in the modern era. From the Russian Constructivists of the '20s to the American Minimalists of the '60s, the blunt instrument of sculpture has been used in various attempts to finish easel painting off, but without success. Over time, it appeared to many not-so-innocent bystanders that it would be the disciples of Marcel Duchamp who would finally accomplish this long-predicted end. Their weapon of choice was the slow poison of irony. Injected into advocates and practitioners of an art form, irony may at first instill a dizzying exhilaration, but it soon triggers a paralyzing self-consciousness, and eventually kills with a corrosive removal of all conviction. Once it has been fully absorbed into the system, there is no known antidote — only relative degrees of damage.

Some painters, however, seem to have been born immune to irony's effects. Brice Marden is notable among them. Ardently embracing painting's history, recent and remote, Eastern as well as Western, he has explicitly cited affinities with everyone from the Spanish Baroque realist Francisco de Zurbarán to the Tang and Sung Dynasty calligraphers of China. So doing, he has faced dangers other than irony's lethal toxin.

A contemporary of the Minimalist sculptor and fellow Yale graduate Richard Serra (see p. 118), Marden started out in what many thought of as the aftermath of American painting's most glorious episode. Spanning the paradigm-setting improvisations of Willem de Kooning and Jackson Pollock, the sedimented icons of Jasper Johns, the one-, two-, or three-tone abstractions of Ellsworth Kelly, and the nested geometries of Frank Stella, that epoch had left behind a rich but daunting legacy, threatening anyone who drew directly upon it with the taint of "follower."

Instead of shunning this heritage, Marden has gracefully acknowledged it. His willingness to do so may be taken as a sign of "mainstream" American modernism's maturity. For as avant-gardes age and become tradition, those most sincerely committed to the aesthetic principles they represent, and most hopeful that those principles can still engender fresh if not altogether "new" art, have only one alternative: that is, to wholly absorb what is given them with the aim of finding unexploited uses for preexisting models. Marden's stage-by-stage assimilation of the work of his predecessors

bears this out. As a guard at the Jewish Museum, New York, he spent hours in the company of Johns's work during the artist's 1963 retrospective there, and the paintings and drawings he began producing only a few years later bear the positive stamp of Johns's influence, even as they do that of Kelly's multipanel pictures. *Avrutun* (1971) and *Untitled* (1970–73) are prime examples of this astonishingly assured early phase of his career.

In *Avrutun*, Marden, like Johns before him, turns to the previously neglected medium of encaustic — pigments dissolved in molten wax, which, once congealed, retains a soft sheen, as if the color suspended in the medium emitted heat as well as light. Thinly applying this material with a palette knife, Marden built up the suave surface of the work in stages, leaving traces of earlier color choices at the edges of each of the panels. A dark slate gray peeps out from under the light cement gray that fills the lower panel, while purple grays show around the sides of the ocher tone that fills the upper panel. This tinge of purple — a muted complementary of the soft greenish yellow covering it — is most apparent at the horizontal seam where the twin canvases that make up the work abut. Through this direct confrontation of the two main hues (one warm, one cool), an opposition further activated in the discreet contrasts provided by the marginally visible underpainting, Marden creates a vibrant chromatic composite out of subdued monochrome layers superimposed upon or adjacent to one another.

The artist's way of dealing with graphic work at this time in his career was much the same. Freehand drawing as such was a subordinate aspect of his method, but an important one even so. Usually starting with a grid, Marden focused his efforts on imbuing this rigid armature with a suave physicality not found in the art of his Minimalist peers. Often his works on paper approach the material presence of his paintings. The coal-hard luster of the drawing *Untitled*, for example, results from the pressing of a mixture of graphite and wax (a combination recalling encaustic) onto the paper inside the rectangular contour. The end product of this labor-intensive mark-making process is a tacitly rich but visually impenetrable entity, a black pictorial space on the verge of becoming a black object.

Embedded in the uniform texture of Marden's paintings and drawings of this time was a palpable gestural force as

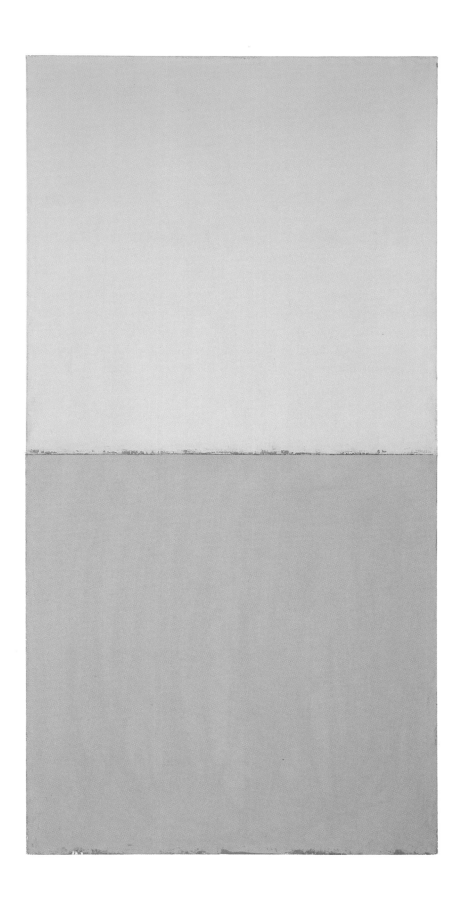

Brice Marden. *Avrutun*. (1971.) Oil and wax on canvas,
72 x 36" (182.9 x 91.4 cm). Fractional gift of Werner
and Elaine Dannheisser

insistent as that of the Abstract Expressionists. Beginning in the mid-'80s, he let those gestures show, by allowing the drawn image to separate from the tinted ground. Reversing the logic of reductive art, Marden has gradually shifted from single, barely uninflected panels, to simple pairings like *Avrutun*, to more complex juxtapositions of three or more panels (combinations of vertically and horizontally arranged narrow rectangular sections, resulting in post-and-lintel, columnar, or cruciform compositions), and finally to intricately delineated field paintings. In short, he has traded the minimal absolute, and all the certainties it stands for in modernist thinking, for compositional relativity and the ethic of creative uncertainty.

Suggestive of nets and webs, the open tracery in *Vine* (1992–93) and related works also recalls Philip Guston's loosely snarled drawings of the late 1950s and early '60s, as well as the interstitial linear element in the flagstone pattern mimicked by Johns in paintings such as *Harlem Light* (1967). Meanwhile both Johns and Marden invoke the allover abstractions of Pollock. But where Johns's picture retains the quality of a relief, Marden's delicately articulated canvases open inward to gossamer strands wafted by fluid currents. Once the precocious master of opaque layering — as in *Avrutun* — Marden now paints in faint, unraveling strokes and shadowy washes, or draws — as in *St. Bart's 10* (1989–91) — with a skittering line. The effect is, in either case, a pliant scaffolding that occupies its environs but tactfully refuses to grid them or fix their exact depth or shallowness.

In 1991, Marden showed a large group of drawings and paintings of this type as the "Cold Mountain" series, a title referring to an eighth-century Chinese hermit, Han Shan. The connection he made to Chinese art brings to mind the work of Mark Tobey, a student of Japanese culture whose white so-called "writing paintings" suggested Zen pictographs, and of Franz Kline, whose boldly gestural black-on-white abstractions were often compared to calligraphy, despite Kline's resistance to this idea. In intention as well as style, recent works such as the "Cold Mountain" group and *Vine* and *St. Bart's 10* occupy the middle ground between Tobey and Kline. Like Tobey, Marden has explicitly acknowledged his Asian inspiration, and like Tobey he bases his idiosyncratic interpretation of calligraphy on an overall fabric of translucent strokes. But as with Kline, his ideal scale is larger than Tobey's, though not as large as Kline's at his most expansive (or for that matter as Pollock's at his). *Vine* is an example of Marden working at his best on a canvas at the outer limit of scale suited to his discursive manner.

The combination of respectful ambition and genuine refinement found in Marden's work is the mark of a traditional painter. Unshaken by avant-garde attacks on his medium, the artist has sought to synthesize once divergent approaches to it, and so add to the still unfolding history of abstraction. The trajectory from *Avrutun* to *Vine* describes a significant move along this chosen path. As with all purposefully traditional enterprises, the goal is not progress toward the unknown but fulfillment of an existing promise. The rewards for such effort — manifest in Marden's work generally, but especially so in these four examples — is art of great stylistic fluency and beauty.

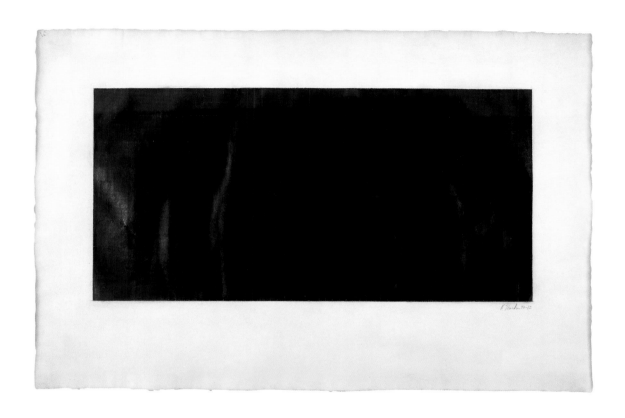

Brice Marden. *Untitled*. 1970–73. Graphite, wax, and paper, 26 x 40" (66.1 x 101.6 cm). Fractional gift of Werner and Elaine Dannheisser

Brice Marden. *St. Barts 10*. 1989–91. Ink on hand-made paper, 10½ x 15⅞" (26.7 x 40.3 cm). Gift of Werner and Elaine Dannheisser

Brice Marden. *Vine*. 1992–93. Oil on linen, 96 x 102½"
(243.8 x 260.3 cm). Fractional gift of Werner and
Elaine Dannheisser

Reinhard **Mucha**

German, born 1950

Of the German artists who have followed in the wake of Joseph Beuys, Reinhard Mucha is probably the least well-known to Americans. Born in Düsseldorf in 1950, he attended the Kunstakademie there from 1972 (when Beuys was dismissed for academic insubordination) to 1973, then returned in 1975 to continue his studies, which he completed seven years later. Mucha was still in school when he had his first one-person show, and by 1982, the year of his graduation, he had begun to exhibit with increasing frequency in Germany and abroad. It was not until 1993, however, that Mucha had his first solo exhibition in the United States, though he had previously appeared in several group exhibitions here and in Canada, notably the *European Iceberg* show at the Art Gallery of Ontario, Toronto, in 1985, the Carnegie International in Pittsburgh in 1991, and *Allegories of Modernism: Contemporary Drawing*, at The Museum of Modern Art in 1992.

Against the backdrop of Anselm Kiefer's renown in this country from the early 1980s onward, and the more gradual but steady exposure given Sigmar Polke and Gerhard Richter, Mucha's comparatively slow rise to prominence is hard to account for. In part the discrepancy may be ascribed to his customary guardedness, coupled with the view shared by a number of European artists of his generation that insofar as the focus of the art world had shifted away from New York and back to the Continent, regular appearances in the United States were no longer an absolute prerequisite for launching or sustaining a major career. Dovetailing with this European diffidence toward the New York scene is the clear American preference in recent years for European pictorial art over more abstract or conceptual forms. Even Beuys suffered from this tendency of taste. Despite the furious traffic in artworks during the 1980s, and the constant exchange of information through magazines, catalogues, and other means during that decade and since, an abiding cultural gap separates the art worlds on either side of the Atlantic. Mucha's lopsided reception locates that divide.

Mucha's sculptures are typically composed of a mixture of found objects and unused bulk materials. Neon tubing, ladders, fans, chairs, cabinets, shelving, and other office furniture are thus combined with antique armoires, benches, and heavily worn doors. Whether the components are old or new, the emphasis is on their generic qualities rather than their unique characteristics, a stress reinforced by Mucha's habit of building intricate installations out of multiples of any given element. In this way a dozen or more molded plywood chairs or stacked steel drawers become a baroque equivalent of Carl Andre's modular metal plates, common bricks, or oaken beams.

Lettering often plays a role in Mucha's work as well. Generally large scale and in block type, these letters and the words — usually place names — they spell out have the same impersonal and imposing aspect as the objects with which they are associated. Indeed they seem objectlike themselves. Given this fact, the basic sense they make contrasts sharply with the obvious abnormalities of the rich vocabulary that Mucha has concocted out of his rudimentary sculptural alphabet.

As we know, verbal language acquires meaning through use; by appearing in a variety of contexts, a single word gains dimensions far beyond its original or most literal definition. This holds equally true of visual language: in practice the raw or found materials of sculpture develop their own etymology. If the commonplace significance of objects depends for the most part on their intended place and function, then their deliberate displacement, and the corresponding disregard for their function, render them meaningless in the ordinary way, but may lend them unimagined significance in their new "semantic" setting. To the extent that objects are also identified with previous displacements or disturbances in their function, then each additional step in that direction bears not only on their commonplace significance but on the history of their artful misuses as well. Hence Mucha's resort to the aesthetic strategies of the assisted readymade causes us not only to think again about the status of the particular elements he has chosen to relocate in his work, but at the same time to consider his relation to Beuys, and, in turn, Beuys's relation to Marcel Duchamp, Dada's dada of them all.

Kalkar (1988) places just such demands on the viewer. Named after a town Mucha saw marked on an old German railway map — as are numerous works from this period — the piece consists of an unhinged, glass-covered door frame, positioned sideways to serve as the front molding of a two-shelf cupboard lined with dark felt. At once obvious (all parts of the sculpture are easily inspected) and puzzling (what possible contents could it have been designed for?), the work is both a display object and an object on display, a thing

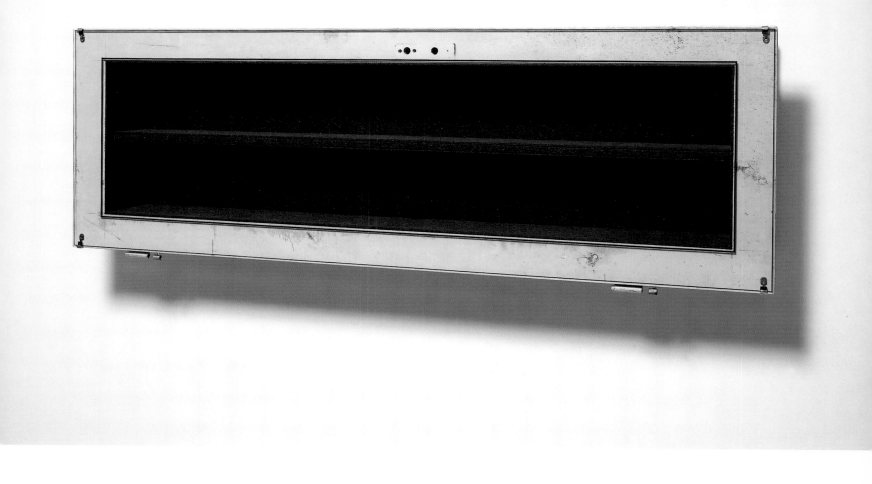

Reinhard Mucha. *Kalkar*. 1988. Wood, metal, felt, and glass, 27½ x 78⅞ x 12⅜" (69.8 x 200.3 x 31.4 cm). Loan to The Museum of Modern Art, New York, from The Dannheisser Foundation

apparently intended to show other things yet that, absent any contents, shows itself.

On its own, *Kalkar*, with its time-patinated frame, touch-obstructing glazing, and vacant, light-absorbent interior, is an evocative work. Among the sources of its poetics, however, are Beuys's vitrines (represented in this collection by *Celtic*, 1971–84, p. 32), and comparison with them plainly demonstrates the subtle changes that Mucha has wrought on that model. Beuys preserved the relics of his activity as a "social sculptor" in glass cases of the sort found in ethnographic collections. Taking Duchamp's tactic of injecting nonart or antiart objects into the art setting in order to subvert aesthetic decorum, he gave it a 180-degree twist by museologically sanctifying his versions of such nonart, antiart, or more

accurately, perhaps, Ur–art objects. For his part, Mucha has removed such objects altogether, concentrating entirely on the conventions of presentation. The simulacrum of the Beuysian display case that he has constructed is a mysterious but conspicuously empty vessel. Under the superficially makeshift appearance of Mucha's assemblage one can also discern the lines of a cold contemporary classicism, a mood utterly distinct from the warm albeit morbid romanticism of Beuys. Where Beuys's vitrines are sensual and elegiac, Mucha's are stark and funereal. As such, *Kalkar* and kindred works may be examples of a formal idiom approaching the end of its development, but in Mucha's hands that idiom is still capable of powerful inflections.

Bruce **Nauman**

American, born 1941

"Think," commands the echoing voice as a head bobs up and down at the edge of the television screen, like a man struggling to stay above water. The man is Bruce Nauman, and for thirty years he has been doing just what he says, and, in the process, making others do so as well. No other artist of his generation has been so insistent in the conceptual and psychological demands they make on the public, or so persistent and inventive in varying the form and tone in which those demands are made. Simply keeping track of the diversity of Nauman's output requires effort, while puzzling through the riddles of some pieces, or enduring the aggression of others, calls for an intellectual rigor and an emotional stamina that set a uniquely high standard for seriousness in contemporary art.

Like Samuel Beckett, an author he greatly admires, or Ludwig Wittgenstein, the philosopher of language whose writings define the basic terms for many aspects of his work, Nauman addresses complex issues with great economy. The essential questions — and Nauman's art consists of leading questions, with no unambiguous answers — are constant insofar as they concern eternal tensions between life and death, love and hatred, verifiable truth and gnawing existential doubt, yet to retain their resonance and urgency they are at the same time constantly in need of concise and exacting restatement. By videotape, by drawing, by sculpture, by installation, by neon, Nauman rephrases these questions in a hybrid contemporary idiom that for all its novel and sometimes daunting elements has been devised precisely in order to connect in as many ways as possible the thought of the artist with the experience of the viewer. Far from playing hard-to-get with his audience, Nauman seeks to involve people with hard-to-grasp ideas and hard-to-face uncertainties or ambivalences, and he is prepared to use any method — formal contradictions, verbal gymnastics, blunt declarations, disturbing images, raw humor — to push aside distractions, break down resistance, and make contact. Correspondingly, the unease created by Nauman's all-out and all-fronts assault on his own and other people's mental habits expresses itself in many ways: recoil at the sight of an apparently grim object, confusion at the sight of an inexplicably abstract one, surprise at the intensity of sounds or lights, embarrassed laughter at a crude joke or cartoon. Whatever

that discomfort's manifestation, however, its importance is the same. For Nauman, thinking is feeling. To do the one is to do, even to be impelled to do, the other.

At one level, *Perfect Door, Perfect Odor, Perfect Rodo* (1973) is a simple word game, of the kind the artist started playing early in his career. (Customarily Nauman worked the verbal changes out on paper, as demonstrated by *Untitled*, 1973 — the study for *Perfect Door* — and other drawings, including one from 1966 in which he rearranges the tag line of Elvis Presley's classic song "Love Me Tender" and reduces it to alliterative gibberish.) Nauman's decision to execute this text in neon followed the example of previous works in that medium, the first important one, from 1967, having been inspired by an abandoned beer sign that hung in the space he rented as a studio. Although neon had been used as a means of artistic expression since the late 1940s, it had generally been chosen for its abstract beauty, or to comment on consumer culture. Nauman was among the first artists to see it as a way of posing conceptual problems to the public, or, put differently, of advertising philosophical ideas. *Perfect Door, Perfect Odor, Perfect Rodo* is a case in point: by means of these anagrams, Nauman sets up an equation demonstrating the basic linguistic fact that words are not intrinsically meaningful, or inherently related to the things to which they refer, and that the same group of letters can make perfect sense in several ways — or perfect nonsense.

White Anger, Red Danger, Yellow Peril, Black Death (1984) pursues this logic further, moving from the strict connotative significance of language to its denotative functions and then attaching those verbal constructions to a sculptural equivalent. Using four colors in the title to modify four nouns, each of which specifies an extreme emotion or situation, Nauman describes a world at risk. Beside their already ominous literal sense, the pairings invoke perennial fears and prejudices: racial hostility, communist threat, Asian hordes, the plague. In the simplest possible terms, Nauman thus raises the specters that haunt our political reality, and does so without recourse to the moralizing rhetoric that removes the sting from so much political art. The work's hanging crossbars with capsized color-coded chairs symbolize the precarious global equilibrium that results from the animosities and tensions conjured up by the title. Moreover, by alluding to

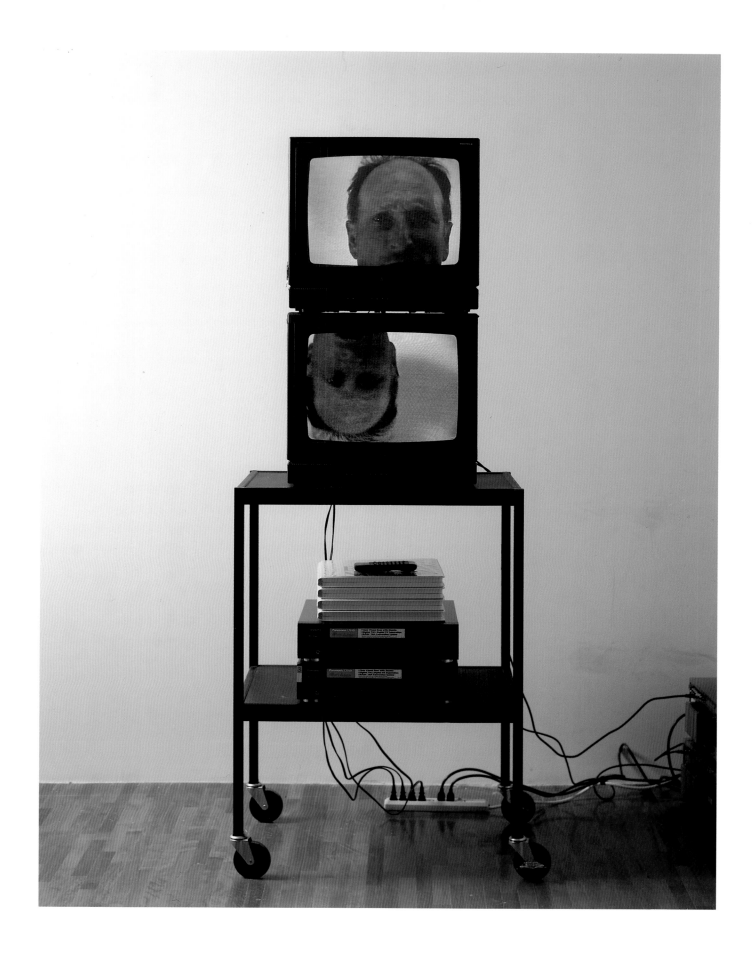

Bruce Nauman. *Think*. (1993.) Video installation:
two 26-inch color monitors, two laser-disc players, two
laser discs (color, sound), and metal table, dimensions
variable, overall: 80 x 30 x 20" (203.2 x 76.2 x 50.8 cm).
Gift of Werner and Elaine Dannheisser

the nineteenth-century French physicist J. B. L. Foucault's theory that a pendulum of sufficient size would register the oscillations of the earth, Nauman kinetically links the axial structure he has made, the room in which it is suspended, and the spectator who walks cautiously around it to every other part of the strife-ridden planet.

Nauman's general outlook is correspondingly pessimistic, although pathos and tragedy frequently assume a comic guise in his art. The comedy can be chillingly burlesque, as in *Dirty Story* (1987), where a woman costumed as a court jester tells a well-worn shaggy-dog story of lust, ineptitude, and calamity, or it can be harsh, as in *Punch and Judy II Birth & Life & Sex & Death* (1985), a preparatory drawing for a multiphase neon work in which the aforenamed puppet characters appear as a naked couple who engage in oral sex, attack each other with weapons drawn, and commit suicide, all at the same time. Still more upsetting is the installation *Learned Helplessness in Rats (Rock and Roll Drummer)* (1988). In a video projection, a teenage boy drums furiously. Meanwhile a transparent plastic maze littered with rodent droppings is constantly scanned by an overhead surveillance camera, its feed alternating, on two monitors that bracket the labyrinth, with tapes of a rat formerly trapped within the maze. The drums are loud, the equipment devoid of visual pleasure, the maze sharp-cornered and sickly yellow, and the signs of frustrated habit in the movements of both the boy and the rat are painfully similar. In sum, this is an infernal place to be, yet also an enthralling one that is difficult to leave. That mixture of repulsion and attraction is a familiar dynamic in Nauman's work, but the focus of such divided consciousness varies. In this instance, the artist's preoccupation is the social and scientific myth that human nature can be improved by controlled environments and behavioral retraining. Having been drawn toward psychology when he was a college student, Nauman now takes a dim view of such claims and methods, and suggests that the opposite is just as likely to be true: what people may learn from rats is not how to improve their lot but how helpless they are to change it.

Nauman's more traditional sculptures also involve reversals. Sometimes they are almost entirely abstract in character. *Triangular Depression* (1977), for example, is to all appearances a Minimalist work. Roughly made of fiberglass and plaster over a steel-bar armature, the piece is a faceted geometrical compound — the meeting of three triangular planes at a single point producing a shallow inverted pyramid that is supported by three radiating walls braced on all sides by crossed rods. Open to view in all dimensions, the piece makes no distinction between inside and outside; it is a geometric shell that implies volume but has none of its own. Within a few years, the vocabulary of shape and system of construction developed in *Triangular Depression* evolved into a series of large-scale models of subterranean tunnels, which in turn led to Nauman's rat-maze rooms.

By contrast to *Triangular Depression*, *Three Part Large Animals* (1989) is figurative, but in its fashion it is also a counterpart to the torturous *Learned Helplessness in Rats*. That said, it owes its violent disjointedness to a formal operation as simple as those in *Triangular Depression*, and remarkably similar to those in *Perfect Door, Perfect Odor, Perfect Rodo*, in that the taxidermy dummies that compose it have been segmented and reassembled as if they were corporeal anagrams. Finally, *Hanging Heads # 2 (Blue Andrew with Plug / White Julie, Mouth Closed)* (1989), with its morbid skin tones and inevitable suggestion of decapitation, might also be mistaken for a pair of solid versions of the man on TV who, upside-down and right-side-up, repeats ad infinitum "Think." He is raucous and animated, the two wax heads are mute and inert, but the imperative is the same as in all Nauman's production. One may not like the manner of its presentation, or the reflections and responses it stirs, but by force of Nauman's many-sided artistic personality it is a challenge that is all but impossible to refuse.

Bruce Nauman. *Learned Helplessness in Rats (Rock and Roll Drummer)*. (1988.) Video installation: Plexiglas maze, closed-circuit video camera, scanner and mount, switcher, 13-inch color monitor, 9-inch black-and-white monitor, video projector, two videotapes (color, sound), dimensions variable. Gift of Werner and Elaine Dannheisser

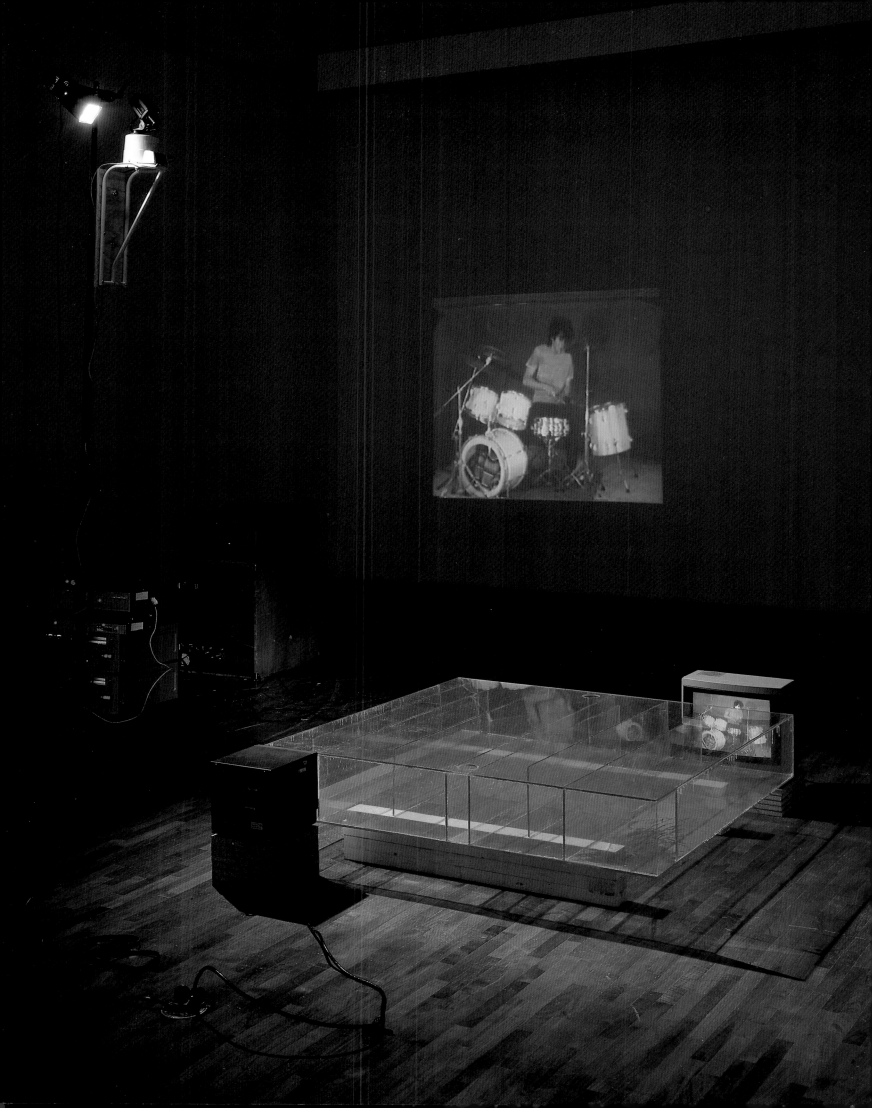

Bruce Nauman. *Untitled (Study for Perfect Door, Perfect Odor, Perfect Rodo).* 1973. Pencil and crayon on paper, 30 x 40" (76.2 x 101.6 cm). Gift of Werner and Elaine Dannheisser

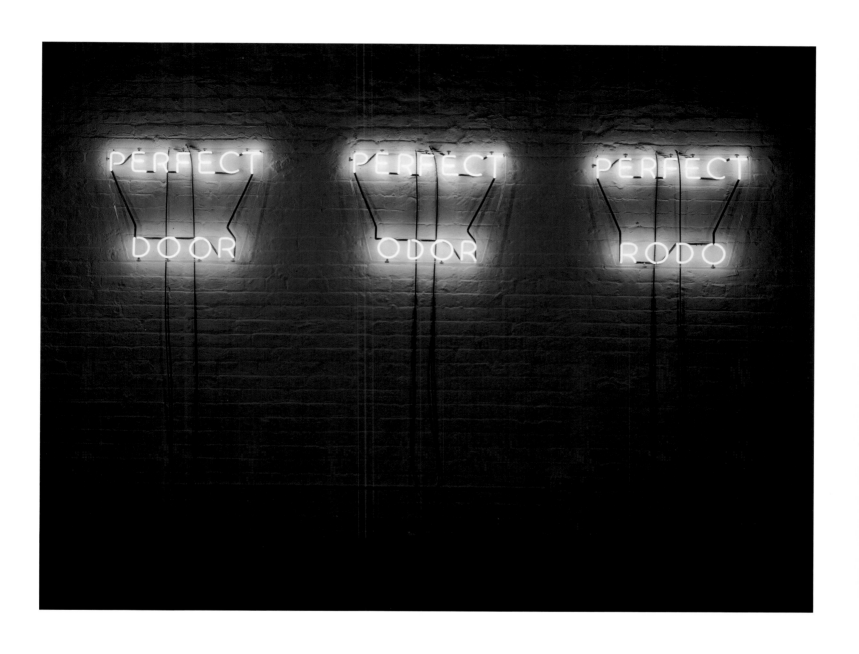

Bruce Nauman. *Perfect Door, Perfect Odor, Perfect Rodo.*
(1972.) Neon tubing and wires with glass-tubing suspension frame, three units, each 21⅜ x 28⅞ x 2¼" (54.3 x 73.3 x 5.7 cm). Gift of Werner and Elaine Dannheisser

Bruce Nauman. *Triangular Depression*. (1977.) Steel mesh, steel rods, burlap, and plaster, 1' 9" x 10' 1" x 8' 7" (53.3 x 307.3 x 261.6 cm). Fractional gift of Werner and Elaine Dannheisser

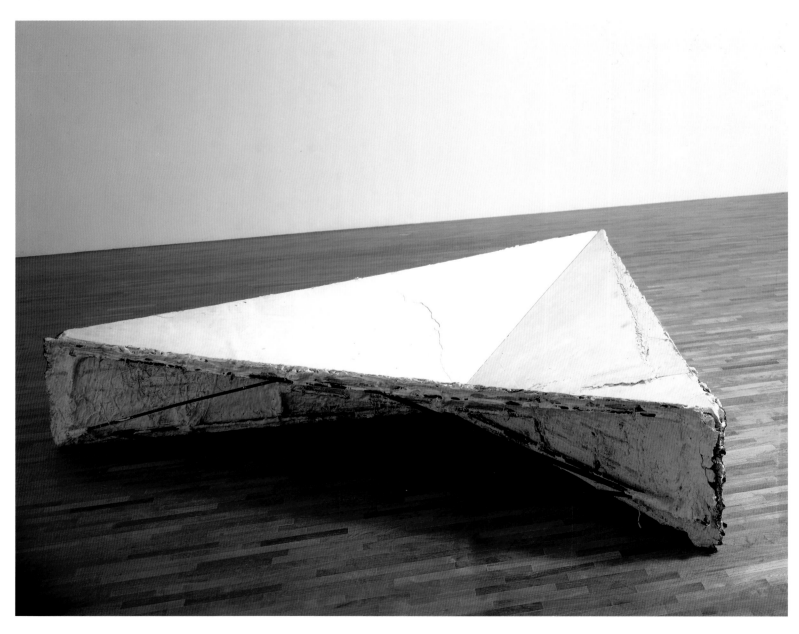

Bruce Nauman. *Hanging Heads # 2 (Blue Andrew with Plug/White Julie, Mouth Closed)*. (1989.) Two wax heads and wire, each head c. $11^{7}/_{16}$ x $9^{7}/_{8}$ x $6^{11}/_{16}$" (29 x 25 x 17 cm), hung $72^{13}/_{16}$" (185 cm) apart and $72^{13}/_{16}$" (185 cm) above the floor. Gift of Werner and Elaine Dannheisser

Bruce Nauman. *Dirty Story*. (1987.) Video installation: two ¾-inch videotape players, two 16-inch color monitors, two videotapes (color, sound), dimensions variable. Gift of Werner and Elaine Dannheisser

Bruce Nauman. *White Anger, Red Danger, Yellow Peril,
Black Death.* (1984.) Two steel beams, four painted
metal chairs, and cable, overall: 5' 2¾" x 17' 11⅛" x
16' (159.4 x 546.4 x 487.7 cm). Fractional gift of
Werner and Elaine Dannheisser

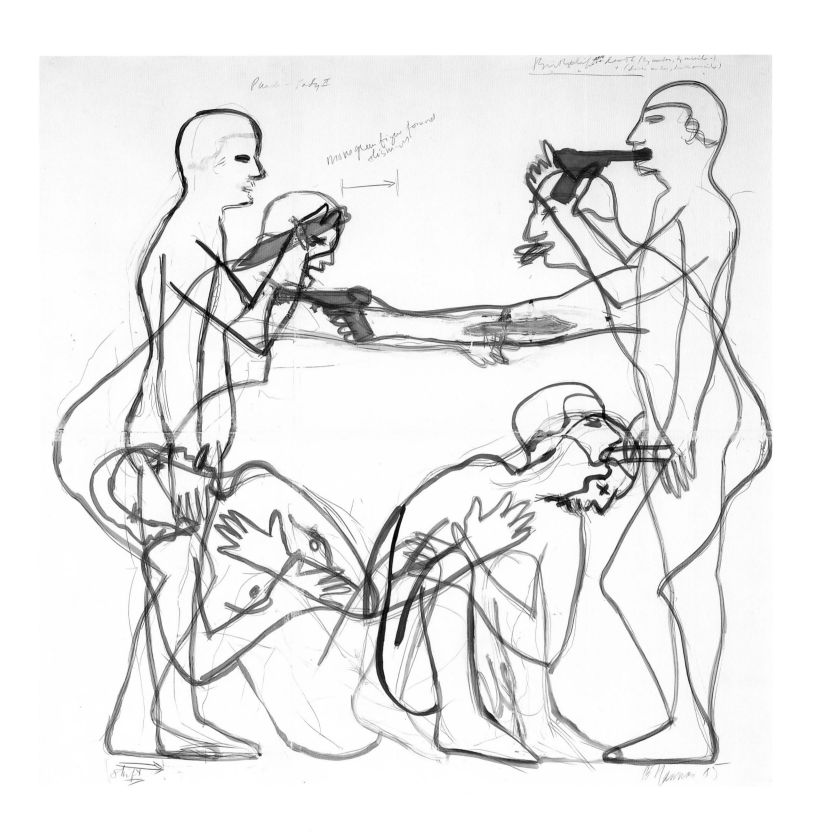

Bruce Nauman. *Punch and Judy II Birth & Life &*
Sex & Death. 1985. Tempera and graphite on paper,
75½ x 72½" (191.8 x 184.2 cm). Gift of Werner and
Elaine Dannheisser

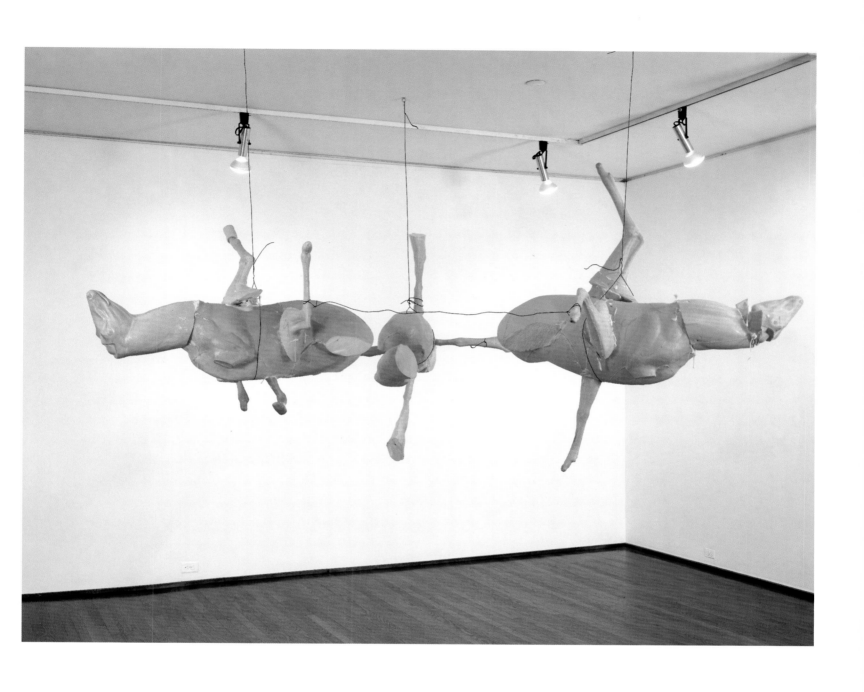

Bruce Nauman. *Three Part Large Animals*. (1989.)
Polyurethane foam and wire, 55 x 110 x 100"
(139.7 x 279.4 x 254 cm). Gift of Werner and
Elaine Dannheisser

Sigmar **Polke**

German, born 1941

"He is a font of Ideas. Any one move can provide a career for a lesser artist." This estimation of the German artist Sigmar Polke, made in the 1980s by his American contemporary John Baldessari, has since been reaffirmed many times over both by Polke's continuing aesthetic ingenuity and by the ever-growing number of artists whose work is indebted to his. A stylist, satirist, and pictorial magician, Polke has eschewed formal consistency of any kind, turning to whatever medium suited his need or whim in a given circumstance. As a painter, printmaker, installation artist, photographer, and performer— and often enough working in several of these capacities at the same time—Polke has mixed media, symbolic systems, and poetic messages with such marvelous alacrity that the defining characteristic of his persona has become its sheer elusiveness.

Polke's peers, including fellow students at the Düsseldorf Kunstakademie such as Anselm Kiefer, his junior by several years (see p. 74), and Gerhard Richter, his close collaborator, not to mention the school's unofficially presiding figure, Joseph Beuys (see p. 30), have also frequently been hard to pin down. But there are revealing differences between Polke and these artists, not just in the light they shed on his quick-silver identity but in what they say about the situation in Germany from the 1960s to the present. Like Kiefer, Polke has looked long and hard at Romantic painting and American-type abstraction, but unlike Kiefer he is neither a romantic nor an expressionist himself. Like Richter, he compulsively switches artistic manners, pitting one against another in sequential works or in the same work, yet he does not share Richter's critical severity or his skepticism of the avant-garde. And like Beuys, finally, he is a myth-maker and self-made magus, but while Beuys, when leaning toward Nordic tradition, chose to impersonate the fatherly and all-seeing Odin, Polke has seemingly preferred the role of Loki the trickster.

Insofar as the weight of history has been a motivating force in German art since World War II, the weight of ideology played a comparably determining part throughout the Cold War. This is especially true for artists who grew up in what was formerly communist East Germany and later made their way to the West. Such was the case with both Polke and Richter, who joined together in 1963 to launch an art movement they labeled "Capitalist Realism," thereby mocking Socialist Realism, the state-sanctioned style of the Soviet bloc, while also setting themselves apart from American Pop, which, still new in its native land, was just then becoming known in Europe. The crude choice offered to artists of Polke's age and milieu was between the USSR and the United States. Dissatisfied with these dichotomous alternatives, Polke and Richter sought out a "third way" that acknowledged the political and cultural power of these antagonists for what it was without being overawed by either of them. Theirs was an anti-ideological stance that made the most of the contradictions facing them for the sake of both freedom and fun.

Quick to grasp ideas coming from all quarters, Polke and his colleagues were even quicker to adapt them to their own purposes. And so, just over a year after Andy Warhol and Roy Lichtenstein had first started imitating the images and processes of commercial art in their work—in particular, the tone-creating system of benday dots—Polke began on his own to explore this and related techniques, eventually including stencils, the use of spray paint, phototransfers, collaged fabric substitutes for the artist's traditional canvas (a device reminiscent of Robert Rauschenberg's "Red Paintings" of 1953–54), and even collective creativity. (In his variation on Warhol's Factory, Polke turned over some aspects of his work to friends with whom he lived on a commune in the 1970s.)

Although the paintings and drawings in this collection postdate these experiments, they are totally in line with them. In *Untitled* (1969), the subtle meshing of screened dots evokes a clouded-over landscape; in *Menschkin* (1972), a sea of heads is stenciled onto a snakeskin-patterned cloth with Pollock-like red arabesques zigzagging across the top. *Untitled* (1971), by contrast, is loosely drawn, though the shapes and images hew closely to the look of copy-book commercial illustration. This impression is underscored by the symmetrical Rorschach-test mirroring of the central elements, which consist of the bust of a man and the body of a nude woman, hinged together at the bottom by the caricatural likeness of a demonic clown, who may well be read as the mischievous Polke's stand-in. The gesture in *Untitled* (1983) is less mechanical, but the system of overlays is the same, as is at least one of the motifs, a disembodied eye staring out at the viewer. Carrying this superposition of fragmented forms still farther, Polke resorted to translucent textiles, which—as in *Untitled, Number 5* (1988)—

Sigmar Polke. *Menschkin*. 1972. Synthetic polymer paint on fabric, 39½ x 31½" (100.3 x 80 cm). Gift of Werner and Elaine Dannheisser

he painted on both the front and the back with resinous pigments so that as light traveled through them, some of the composition from one side would visually dissolve into the composition on the other side. The whole could only be known by moving around the object and mentally "laminating" the remaining parts still isolated from each other on either side. Meanwhile, *Der Ziegenwagen* (The goat wagon, 1992) is Polke at his full-blown best. On a background consisting of floral and geometric tablecloths stitched edge to edge, Polke has printed an enlargement of an old photograph of a peasant boy with a goat cart, and has embellished the picture overall with strokes and splashes of white, suggesting badly developed film stock or the drips of action painting.

The visual complexity of these paintings and drawings is matched by their thematic obscurity. One thing is certain, however: to whatever degree Polke's formal devices resemble those of American precedents, he does not mean the same things by them. In purely formal ways, Polke's version of painterly abstraction is without the strain and anguish of New York Abstract Expressionism, just as his variants on Pop lack the hard impersonality of Lichtenstein and Warhol. Differences in context have some bearing as well. After all, Europe in recovery from the late war was not the same place as America in the first flush of superpower status and supermarket shopping. In America, alienation wore two guises: bold but amorphous abstraction and bold but banal figuration. In Europe, things were frequently less clear-cut, as was the reality behind the image.

Thus, by comparison to Lichtenstein's crisp dot-pictures, Polke's *Untitled* (1969) is ominously fuzzy: who are the men in the foreground, and what fire or explosion has caused the cloud above them? In contrast to Warhol's stark tabloid

pictures and portrait heads, the crush of faces in Polke's *Menschkin* seems indistinct, but then mass man in modern Germany wasn't just John Q. Public, he was an unstable political integer caught in the web of great events.

While American Pop tended toward ironic overstatement, Polke favored an almost off-hand clash of codes in which none was allowed to dominate. Extremes thus meet, fuse, and efface each other in a series of kaleidoscopic elisions. Like a cardsharp shuffling his deck before the eyes of a suspicious but mesmerized mark, the artist publicly sorts through a huge array of images that evoke the past as often as they do the present, the sublime as often as the ridiculous. As mindful of history as he is, Polke has generally sidestepped direct mention of the Nazi era — a further difference from Kiefer and Beuys. Instead he has borrowed genre vignettes, rococo designs, and ornate grotesques from seventeenth-, eighteenth-, and nineteenth-century sources, calligraphic motifs from old master engravings, and ancient pictographs like those in *Untitled, Number. 5*. Then, throwing in the trashiest of contemporary cartoon drawings for good measure, he has immersed them all in murky atmospheres of tone and color.

The result is a pictorial witches' brew that increasingly evokes the allegorical monstrosities of Goya. Indeed there is a saturnine quality to Polke's gamesmanship, and it permeates everything he touches. Polke is playing hard but is also playing for keeps. His refusal to swear allegiance to any aesthetic creed goes deeper than a simple desire on his part to raid his cultural heritage at will. It is rooted in a quite reasonable fear that dogmatic principles of any kind lead to sterility or, as this century has shown, far worse. Better the sulphurous atmosphere of decadence than a surrender to order. Accordingly, Polke has made disorder his medium. No artist of the day seems more comfortable in chaos, nor has anyone shown its attractions more cleverly or more masterfully.

Sigmar Polke. *Untitled*. 1969. Synthetic polymer paint on canvas, 59⅛ x 49⅜" (150.2 x 125.4 cm). Gift of Werner and Elaine Dannheisser

Sigmar Polke. *Untitled*. 1983. Gouache on paper,
39 x 27⁷/₁₆" (99.1 x 69.7 cm). Gift of Werner and
Elaine Dannheisser

Sigmar Polke. *Untitled, Number 5*. 1988. Oil on fabric, overall, including wood stand (not shown) and frame: 84 x 45 ½ x 3 ½" (213.4 x 115.6 x 8.9 cm). Gift of Werner and Elaine Dannheisser

Sigmar Polke. *Der Ziegenwagen* (The goat wagon).
(1992.) Synthetic polymer paint on printed fabric,
86 x 118" (218.4 x 299.7 cm). Gift of Werner and
Elaine Dannheisser

Richard **Prince**

American, born 1949

Richard Prince and **Cindy Sherman**. *Untitled.* 1980. Two chromogenic color prints, each 15 x 23" (38.1 x 58.4 cm) sight, 23 x 30⅝" (58.4 x 77.8 cm) framed. Fractional gift of Werner and Elaine Dannheisser

It is easy to forget that the contemporary dialogue between popular culture and Pop art — or more precisely between commercial art and gallery art — has as often as not consisted of a monologue conducted by two alternating halves of a single artistic personality. The talented young who gravitate to New York and other large cities, looking to pursue their creative vocation, as a rule must also look for jobs. Their skills often steer them toward advertising or publishing. Commonly, therefore, young painters, sculptors, and photographers labor by day at drafting tables and computer screens while doing their "serious" work at night.

Some thirty years ago, a sea change in cultural attitudes occurred when what some avant-garde artists did for hire and what they did on their own time began to resemble each other so closely that they could only be differentiated by the critical slant with which the same formal procedures were followed. One particular object seen from separate perspectives tells the tale: the man who designed the trademark Brillo box of the 1960s was an abstract painter of no special distinction, who presumably regarded his invention as artistically inconsequential; it took Andy Warhol — at that time a successful illustrator working in a fey variation on Ben Shahn's earnest style — to turn that Brillo box into a work of art in its own right.

The 1980s saw another generation of artists enter the territory that Warhol, James Rosenquist (a former billboard painter), and others had pioneered in the 1960s. Among them were David Salle, who did layouts for porn magazines; Barbara Kruger, who worked at Condé Nast; and Richard Prince, who held a position at the Time-Life clipping service. Along with inviting new labels — "appropriation" and "deconstruction" — for the ironic recycling of consumer iconography in which they, like their predecessors, engaged, Salle, Kruger, Prince, and others shed a harsh new light on their mass-media prototypes.

Prince's technique for critically distancing viewers from the alternately sleek and trashy sources he was partial to was especially disconcerting because it so nearly approximated the ones employed by the industry that created them in the first place. While Salle painted borrowed images and Kruger combined Soviet-style graphics with dated archival photography, Prince reshot current Marlboro ads or cult magazine spreads and, by a series of photomechanical steps, transformed them utterly, but always in their own terms. His stated aim was to undermine their ostensible truthfulness. "Unlike paint,"

Prince has observed, "the medium of photography also brought with it the element of fact, of nonfiction." And yet, he noted, "most of what's passing for information these days is total fiction. I try to turn the lie back on itself."

Methodical by nature, in 1977 Prince thus moved away from the collages he had previously made from tear sheets collected at Time-Life, or culled from magazines during his off-hours, and began to explore the full range of options that photomontage offered him. Selectively quoting printed images in much the way that contemporary disk jockeys and rappers "sample" other people's records to provide a basis for their own compositions, Prince began to lead the viewer into a hall of mirrors in which the stylistic manipulations of the original are exposed and altered by successive copies that reframe, recolor, obscure, and diffuse its contents. Calling into question the suspect appeal of his deracinated fragments, he also lent them an aura of mystery. This effect is frequently the consequence of his recourse to cinematic conventions, in particular to the graininess and chromatic oversaturation of peep-show clips, or to the angular, high-contrast look of classic film noir. *Entertainers* (1982–83) owes its hellish allure to both traditions. Dramatically cropped, luridly tinted, filtered through geometric patterns, and surrounded by heavy black margins, the banal publicity shots used in it thereby acquire the aspect of freeze-frames from hypnotically alienating low-budget film productions.

Prince's interest in photographic fictions also resulted in an untitled collaboration of 1980 with Cindy Sherman. For the occasion, the two artists donned the same suit and tie and the same Warholesque wig, so that each played androgynous double to the other. Central to Sherman's art (see p. 122), masquerade was only incidental to Prince's, which has since focused on painting, painted reliefs, and text works as well the photo reprocessing seen in *Entertainers*. The appropriation, dissection, and ironic redeployment of found subject matter have remained his primary concern throughout. Of the many artists who have recently devoted themselves to subverting trust in received images, few have been as coldly calculating as Prince, or as disturbingly effective.

Richard Prince. *Entertainers*. 1982–83. Chromogenic
color print, 61½ x 46½" (156.2 x 118.1 cm) sight, 62⅞ x
47⅞" (159.7 x 121.6 cm) framed. Fractional gift of
Werner and Elaine Dannheisser

Robert **Ryman**

American, born 1930

"There is never a question of *what* to paint but only how to paint. The how of painting has always been the image—the end-product." For those educated to the notion that the task of the artist is to find a suitable form in which to present a given content, this declaration by the American painter Robert Ryman may seem to beg the basic question of aesthetic meaning by concentrating exclusively on the issue of technique. However, it is the measure of Ryman's un-equivocal faith in painting's expressive power that he sees no inherent distinction between "what" is said and "how" it is said. As far as Ryman is concerned, form is content. The crucial corollary of this axiomatic belief, which Ryman has dedicated his forty-year career to proving, is that form, even at its most reductive, is infinitely variable, and capable, therefore, of embodying an equally broad range of ideas and emotions.

To test this article of faith, Ryman has placed severe restrictions on his studio practice. A largely self-trained artist—after a stint in the army playing the saxophone in military bands, he left his hometown Nashville for New York in 1952 with the aim of becoming a jazz musician—Ryman bypassed academic figure drawing and painting altogether and began by making small oil and watercolor abstractions on scraps of wallpaper, bristol board, and old gallery an-nouncements. Within a few years of these experiments, the essential terms he would henceforth follow were set.

Although color played an important role in Ryman's art then as now, white was the dominant hue. All others were confined to the underpainting partially seen between the strokes of the central white areas, or at their margins. The natural shades and tints of the many surfaces on which he worked contributed additional chromatic accents: usually favoring the square over alternative rectangular supports, his particular choice of paper, cardboard, canvas, or wood offered him a host of soft yellows, tans, and browns, while his use of unconventional materials such as fiberglass, metal, and synthetic laminates presented him with an array of translucent greens, copper reds, and blue, silver, or putty grays. Finally, by exploring the full gamut not only of artists' paints but of commercial pigments, as well as all the ways in which they might be applied by brush, roller, or knife, Ryman established a palette of whites that permitted him contrasts of warm and cool, thick and thin, flat or crusty, dull or shiny,

that revealed within the apparently limited entity identified by the word "white" a spectrum of almost rainbow breadth, clarity, and intensity.

The two works in this collection make plain the diversity of the formal solutions and evocative effects that Ryman has found in the process of his methodical inventory of painterly "how's." As *Untitled* (1965) and *Convert* (1988) demonstrate, extremes of scale are also important contributors to this subtle aesthetic variety. The first of these two paintings belongs to a series in which the artist filled his canvas with tiers of lateral bands made by the same brush as it sometimes smoothly, sometimes haltingly, moved from left to right or right to left. The spaces between each stroke, and the pinhole dots made by the skipping brush hairs, allow the rich tan of the unprimed linen to show through, as it does on the side of the stretcher bar, where the work's date and the artist's signa-ture appear as active elements in the overall composition. While some works in this group are as large as six by six feet, others are only a fraction of that—*Untitled*, for example, being only eleven inches square. And while in some, the white traverses the surface in wide sweeps, in others the tracks are quite narrow. In this instance, despite the painting's diminutiveness, the strokes are relatively broad. Whether large or small, overall scale does not determine a work's importance, nor are the little paintings studies for the big ones—and whatever the size of the marks, the basic tension between the outward pressure of the horizontal lines and the structural compression of the fully symmetrical ground on which they are laid remains the decisive issue.

Apparently lacking any such painterly incident, the central void of *Convert* hovers before the eye, bounded only by the pale graphite filament running around the perimeter. As the eye becomes acclimatized to this cool, uninflected atmosphere, it becomes aware of the fading in and out of the pencil track, the clear-cut gap in its course at the upper left corner, the glossiness of the paint between the line and the edge as compared to the matte white of the interior, and the brown strip of wood set into the sides of the honeycomb-aluminum-and-fiberglass sandwich on which the canvas is

Robert Ryman. *Untitled*. 1965. Oil on linen, 11¼ x 11 ⅛" (28.4 x 28.2 cm). Fractional gift of Werner and Elaine Dannheisser

mounted. What at first glance strikes one as a dazzling blank thus increasingly acquires definition, as if one were staring into a blinding snowfield out of which gradually emerged the contours of a wire fence, though the artist had no such literal image in mind when he worked.

The visual acuity to appreciate such minute distinctions is not a matter of special aptitude; it lies within the grasp of all who take time to examine the paintings closely. Indeed the paintings themselves may teach the senses this skill as one slows down to take note of what may at first register — if they register at all — as inadvertent or inconsequential nuances. Nothing in a painting by Ryman, however, is unintentional or insignificant. The work is situated at a perceptual threshold where every detail enhances the visibility of every other detail, where pure form becomes pure pictorial poetry.

"In the end I am a realistic painter," Ryman has declared, meaning simply that his paintings should be ap-proached not as abstract symbols but as unique and coherent wholes that are beautiful in a physically immediate way. This said, it is worth mentioning that Ryman's principal role models have been Henri Matisse and Mark Rothko. As surprising as this sounds, given the chromatic lushness of their work and the austerity of his, the association holds true when one considers that like theirs, Ryman's aim has been to create spaces filled with an ideal harmony. "[Rothko's] work might have a similarity with mine in the sense that they may be both kind of romantic," Ryman maintains, adding, "Rothko is not a mathematician, his work has very much to do with feeling and sensitivity." And so it is with Ryman, the rigors of whose art are no more mathematical than those of Rothko's, nor any less a matter of feeling and sensitivity. Like a great musician working within a strict compositional format, his ultimate goal is to instill delight through painstaking notation of the subtlest of structural and tonal variations.

Robert Ryman. *Convert*. 1988. Synthetic polymer paint on cotton canvas mounted on fiberglass with redwood, 72 x 72" (182.9 x 182.9 cm). Fractional gift of Werner and Elaine Dannheisser

Richard **Serra**

American, born 1939

It is customary to think of the avant-garde and the academy as polar opposites, even natural antagonists, and in the nineteenth century this was largely true. Academic art in that period was dictated by principles ostensibly derived from classical and Renaissance art, but lesser talents had turned them into rigid formulas through misunderstanding and misuse. It was against such sterile orthodoxies that Impressionism, Cubism, and other modern movements mounted their attack on sanctioned taste. In our own country during the 1930s, '40, and '50s, a similar battle was fought between defenders of conventional realism and advocates of abstraction and alternate forms of representation. The fact remains, however, that avant-gardes in their hour of triumph often create new academies to replace the old.

This phenomenon is sometimes decried as hypocritical by those who have lost the battle against novel aesthetic practices that in their rise to prominence prided themselves on their antiestablishment status. Still, there is no logical reason why artists who have reconceived the basis for art in their time should avoid propagating their views and teaching their methods. Joseph Beuys seized just such an opportunity when he became a professor at the Düsseldorf Kunstakademie and turned its program inside out to serve his causes (see p. 30). Several American schools have undergone similar transformations, chief among them the art department at Yale University, where the guiding light for many years was Josef Albers, himself a graduate of the greatest of all avant-garde academies, the German Bauhaus.

Richard Serra, arguably one of the most innovative but also among the most widely commissioned and officially honored sculptors of his day, is a pure product of this institutionalization of a formerly insurgent modernism. While a student at Yale in the early 1960s, Serra, then still a painter, worked as Albers's assistant, and helped him to prepare his pedagogical masterwork, *The Interaction of Color*. As Serra's interest shifted toward sculpture, the example of Constantin Brancusi's reductive abstractions offered him an insight the influence of which can be seen in virtually all of his mature works, including those in this collection. "What interested me about Brancusi's work," Serra has recalled, "was how he was able to imagine a volume with a line at its edge — in sum, the importance of drawings in sculpture."

For American artists during the 1950s and '60s, "drawing in space" had generally meant the synthesis of linear and planar elements found in the assemblages of David Smith. In Brancusi, Serra identified a model that instead of involving the juxtaposition of more or less graphic components and more or less objectlike ones, as in Smith's sculpture, used linear articulation and the volume-producing disposition of planes as dimensions of the same forms. The palpable similarity between a drawing such as *Two Rounds* (1991), or even the more gestural and organic *Videy Drawing XIX* (1991), and a sculpture such as *Melnikov* (1987) demonstrates this proposition. Although flat, the works on paper impose themselves physically, the black forms holding their shape in such a way as to mold the blank areas around them, much as Melnikov's T configuration frames and partially encloses the emptiness around it. With the heavy buildup of opaque, waxy pigment on their surface, both drawings possess a tactile weight equivalent to that of the rough steel plates Serra so often uses, while the staggered curving edges of *Two Rounds* in particular cut across the work's two adjoined sheets in the same way as the edge of works such as *Tilted Arc* (1981), *Clara Clara* (1983), and *Intersection II* (1992) slice through air and seemingly bend space in their vicinity. The inherently sculptural aspect of these drawings stands out plainly when compared to the comparable opaque and objective, but still pictorial qualities of Brice Marden's monochrome drawings (see p. 84).

While fellow Minimalists such as Carl Andre developed Brancusi's ideas in the direction of standardized unit-by-unit composition, Serra explored the process-oriented manipulation of raw materials as a means of engendering new abstract forms. He enumerated these sculptural operations in "Verb List 1967–68," which begins, "to roll, to crease, to fold, to store, to bend, to shorten, to twist," and continues for another 101 entries. In this respect a systematizer like his mentor Albers, Serra looked still further back in the modernist past to Russian Constructivists of the teens and '20s, and to the interrupted artistic revolution they initiated and for a brief time installed in power under the aegis of the Soviet government. Before the 1960s, the Constructivists were often given short shrift in art history. The work of Serra and others of his generation who identified with their emphasis on industrial facture restored them to the center of discussion and debate.

Richard Serra. *Videy Drawing XIX*. 1991. Oilstick on paper, 24 x 19" (61 x 48.3 cm). Gift of Werner and Elaine Dannheisser

Konstantin Melnikov (1890–1974), after whom Serra titled his 1987 piece, was a key figure in Constructivist circles. He was an architect by profession, and during the liberal years of communist cultural politics, just after the Bolshevik takeover, he founded an experimental architecture program within the existing Moscow art academy. His teaching focused on four issues. The first concerned volume in relation to the expressive attributes of surface; the second, the relation of weight and mass to volume; the third, construction; the fourth, space. The reasons for Serra's interest in Melnikov are obvious in that they translate the precedent of Brancusi into terms that more exactly accord with Serra's own preoccupation with the relation of weight to support, of cantilevered structure to enveloped or enveloping space, of expressive impact to matter-of-fact physicality.

As a sculpture, *Melnikov* embodies all of these qualities, thereby conceptually paying "in-kind" homage to its name-sake. Resting one hot-rolled steel plate upon another tipped on one end, Serra has created a work as efficient in construction and as firmly balanced in reality as it is precariously heavy and overbearing in appearance. Formally pure and visually dynamic, the work realizes ideals set forth by the original Constructivists, through means that are nonetheless entirely of its own era.

As a whole, Serra's work may be read as the delayed fulfillment of aesthetic hopes first raised shortly after the beginning of the century in a social and political situation almost diametrically opposed to that of America since the 1960s. From this perspective one may look at Serra's work as a radical reinterpretation of the radical propositions of the past. It is the task of the academy to conserve and transmit tradition; the challenge facing the avant-garde is to alter it fundamentally. Now that modernism has to a large extent become traditional, it is unsurprising that the avant-garde should be not only well served by the academy but in many ways at its service. Serra's acknowledgment of Melnikov is in this aspect a recognition of this paradoxical state of affairs. That his sculptural salute is so authoritative is a testament not only to his individual achievement but to the vitality of the lineage in which he has taken his place.

Richard Serra. *Two Rounds*. 1991. Oilstick on paper, 6' 6½" x 12' 9" (199.4 x 393.9 cm) framed. Gift of Werner and Elaine Dannheisser

Richard Serra. *Melnikov*. (1987.) Hot-rolled steel, two plates, each 57½ x 96 x 2" (146.1 x 243.8 x 5.1 cm), overall: 8' 3" x 8' x 10' 10½" (251.5 x 243.8 x 331.5 cm). Fractional gift of Werner and Elaine Dannheisser

Cindy **Sherman**

American, born 1954

Boys play with erector sets; girls dress up and play with dolls. In a society acutely aware of gender prejudice, such clichés have become anathema. The reasons for this are obvious and basically just, but the vehemence with which the clichés have been rejected speaks to two realities. The first and most important is their capacity to harm and restrict the freedom of choice of the individuals on whom these culturally determined identities are imposed. The second and more awkward fact is that, like all clichés, they have an element of truth to them. Whether or not men and women are destined by circumstances or inclination to become engineers or homebodies (and these days they may gravitate toward either option in the expectation of a degree of understanding unknown to previous generations), boys in large numbers do play with erector sets, and girls in equal proportion do dress up and play with dolls.

At any rate, Cindy Sherman did. And she still does. The irony of course is that rather than move on from juvenile role-playing to corresponding adult occupations, Sherman has persisted in her childhood habits, using the techniques of impersonation and psychological displacement she practiced long ago to hold up to general scrutiny the myriad conventional images of women disseminated by the film industry, art history, fairy tales, and gothic fantasy. From the apparently limited premise of mimicry and puppetry in front of the lens, she has created one of the most coherent, critically penetrating, and continuously surprising bodies of work of the last two decades.

As it happened, Sherman's father was an engineer who collected cameras for a hobby, and after several years in college the artist herself turned to photography. For a class project in 1975, she made a time-based series of images for which she made herself up and cast herself as a variety of characters. Two years later she began making uniform black-and-white images that recalled old movies from the 1950s and '60s without actually re-creating particular scenes from them. For these "Untitled Film Stills" Sherman costumed herself in situations that variously invoked Anna Magnani in Italian Neorealist cinema, Marilyn Monroe in Hollywood potboilers, and Cloris Leachman in the 1955 noir classic *Kiss Me Deadly*. As the star of all of these truncated one-frame narratives, Sherman, who is a great actress as well as a great artist, evoked terror, alienation, bawdy verve, cold

hostility, sultriness, dizzy charm, and a host of other parts and moods.

The intelligence of Sherman's art, which toys with authenticity and falsehood, the theatrical suspension of disbelief, and the startling exposure of social lies and cultural manipulations in which the public most often passively collaborates, is evident in her ambivalent regard for the clichés that she simultaneously gives substance to and sends up. Of her own feeling on the subject she has said, "There's also me making fun of these role models of women from my childhood. And part of it maybe is to show these women who are playing these characters—maybe these actresses know what they're doing, know they're playing stereotypes but what can they do." The pathos Sherman sees in their predicament is by extension the pathos that colors the lives of women in the modern world generally, particularly insofar as they compensate for the place they have been assigned by dreaming of more dramatic existences. While much conceptually oriented photography, painting, and text-based work of recent years has analytically dismantled the formal devices that frame visual images from a masculine perspective, Sherman has taken over the prerogative of this implicitly male gaze and held up a mirror to the mirror fictions in which women are asked to see themselves through men's eyes. She thus participates in illusions that she at the same time lays bare.

Untitled #113 (1982) was made later than the original film stills, and is on a larger scale. This color print shares with them, however, a staginess that comes straight off the movie lots. Oversaturated hues and overly dramatic lighting lend the gamin whom Sherman portrays an aura that glamorizes her vulnerable-tough-girl presence while isolating her in a totally artificial realm. This isolation too taps into the mythology of the lonely star whose true feelings almost—but not quite—show through the stylized emotions that consume them as psychic fuel.

The majestic *Untitled #216* (1989) belongs to a series as loosely and provocatively based on the compositional syntax

Cindy Sherman. *Untitled #113*. 1982. Chromogenic color print, 44³⁄₁₆ x 29½" (112.5 x 74.9 cm) sight, 53¼ x 39¼ x 1½" (135.2 x 99.6 x 3.8 cm) framed. Edition: 8/10. Gift of Werner and Elaine Dannheisser

of painting as the film stills were on cinematic effects. In this instance the paradigm Sherman reinterprets is a mid-fifteenth-century Madonna and Child from the Melun Diptych by the French master Jean Fouquet. Sherman approaches this most problematic of female ideals, as always, with a studied straight face. The only giveaway in this picture is the perfectly round bare breast that she offers to the perfectly rigid baby Jesus; cupped over her own breast, this is a plastic "tit" of the variety found in gag or novelty stores.

This intrusion of the grotesque into an otherwise dignified setup becomes more extreme when, as in *Untitled #188* (1989) and *Untitled #250* (1992), Sherman disappears altogether and replaces herself with obscene plastic surrogates. The first of these two images depicts what seems to be the aftermath of a rape, with a limp inflatable sex-doll as the victim, left lying on a hard bed of detritus. The violence of this picture is accentuated by the doll's blank, lipstick-smeared smile, and by the knowledge that this is the face men pay for when they buy such masturbatory products. The second of the two images pushes things much farther. Positioning a rubber mask of a hag atop a rubber shell shaped like a woman's distended breasts and belly, and joining this to a fake pelvis with gaping

hairy genitals that extrude simultaneously fecal and phallic sausages, Sherman creates an in-your-face personification of immodest femininity. She does this, however, as a purposeful challenge to the assumptions that women should be modest, that old age is shameful, and that sex is dirty—and she does it with a vengeance.

In the 1920s, Lon Chaney—who vanished into the roles of the Hunchback of Nôtre Dame, the Phantom of the Opera, and countless other deformed creatures—was known as the Man of 1,000 Faces. Using the props and makeup tricks of the monster genre he pioneered, just as she has reconfigured the erotic *poupées* of the Surrealist sculptor Hans Bellmer in accordance with her own era and point of view, Sherman, a woman of many faces, has progressed from the relatively naturalistic stereotypes of mid-century films to fantastically exaggerated archetypes of romantic fables and low-budget horror flicks. Plainly, dress-up and doll-play can be both serious grown-up business—risky, too—and, in the hands of an artist of Sherman's caliber, as aggressive or as subtle a means of exploring social customs and psychological dispositions as we have.

Cindy Sherman. *Untitled #188*. 1989. Chromogenic color print, 43½ x 65½" (110.5 x 166.4 cm) sight, 45¼ x 67¼ x 2½" (114.9 x 170.8 x 6.3 cm) framed. Gift of Werner and Elaine Dannheisser

Cindy Sherman. *Untitled #216*. 1989. Chromogenic color print, 87⅛ x 56⅛" (221.3 x 142.5 cm) sight, 95⅜ x 64⅛ x 2⅞" (242.2 x 162.8 x 7.3 cm) framed. Gift of Werner and Elaine Dannheisser

Cindy Sherman. *Untitled #250*. 1992. Chromogenic color print, 49⅜ x 74½" (125.4 x 189.2 cm) sight, 51⅛ x 76³⁄₁₆ x 2½" (129.8 x 193.5 x 6.3 cm) framed. Gift of Werner and Elaine Dannheisser

Thomas **Struth**

German, born 1945

"[Photography] is a communicative and analytical medium. For me taking a photograph is mostly an intellectual process of understanding people or cities and their historical and phenomenological connections. At that point the photo is almost made and all that remains is the mechanical process." These are the words of the contemporary German photographer Thomas Struth, and his formally premeditated pictures bear out his claims. Concentrating over the past ten years on three themes — urban landscapes, families, and the complex interaction of architecture, art, and the public in museums — Struth has developed a style of close observation that distinguishes itself as immediately from the tradition of "decisive moment" street photographers as from that of the obviously staged images of postmodernists like Cindy Sherman (see p. 122).

Although Struth's stated aims are fundamentally investigative or reportorial, his compositional approach is much like a painter's. This may in part be explained by the fact that he was a student of the painter Gerhard Richter's at the Kunstakademie in Düsseldorf before he shifted his medium to photography, entering the master classes of Bernd and Hilla Becher. Reproducing photographs in oil, Richter has filtered the stop-action look of snapshots and printed pictures through the conventions of both academic and abstract painting, thus suspending the image in a temporal vacuum. Although sharply delineated where Richter's work is generally blurred, views of Struth's like *Continentale Gummiwerke, Hannover* (Continental tire factory, Hannover, 1984), or *Avenue du Devin du Village, Genf* (Avenue du Devin du Village, Geneva, 1989), nevertheless strikingly resemble Richter's "grisaille" cityscapes of the mid-1960s.

This said, Richter's canvases seemed to be enveloped in a cloud of alienation, while Struth's generally depopulated pictures — he takes them early in the morning, when the streets are vacant and the light consistently revealing — seem curiously inviting. Struth is on intimate terms with strange and neglected places throughout Europe, Japan, and America. Moreover, the sense of timelessness in his images is matched by the feeling that the scenes themselves are already retreating into history. In this respect his aesthetic lineage may be traced not only to the Bechers, and their architectural morphologies, but to Eugène Atget, the determined flaneur and photographic recorder of Paris at the turn of the last century. Like Atget and the Bechers, Struth is a preservationist. In showing how our built

environment looks, or looked, example by example, he is also a critic of the destruction wrought in the cause of progress. He has explicitly asserted this as his purpose: "I have always said with respect to the street photographs that they should pose questions as photography, questions that relate to the future."

In a similar manner, Struth's museum pictures pose questions about the viewing of art, and the conditions in which it occurs. Here again the artist has clearly articulated the basis of his interest: "Today museums are no longer an institution as they were fifteen years ago; they have become an institution which due to its significance or its popularity is comparable to not exactly the shopping mall but the sports stadium field, or to religion. That's why it is a place which is essentially nonprivate."

As *Pantheon, Rome* (1990) shows, however, this paradox — the eagerness with which people flock to museums to experience art as if in splendid mental isolation — is by no means new. The milling crowd craning their necks to gaze up at the Pantheon dome is composed of people who are recognizably our contemporaries, but the pilgrimage they have made is centuries old. Tourists in the late eighteenth century would have worn different clothes, but they would have "looked" in the same way. What has changed in the depiction of such scenes between then and now is not the conduct of the artist's subjects but his vantage point. While genre painters of the past were mainly concerned with attractively portraying famous sites overrun with admirers, Struth's rendering of this encounter emphasizes the act of bearing witness. The absorption or distraction of the visitors interests him more than the thing they have come to see.

What, then, is the position of anyone who comes across such an image? To the degree that their involvement mirrors that of the attentive figures inside the photographic frame, they have in effect been annexed by the image, and so enter into a relationship with the work that transforms them from passive onlookers into self-conscious ones. That is the conceptual turnaround that Struth's museum pictures discreetly effect. "Where the mechanism of spectacle, of contemporary museum-business are staged, my photographs can offer a reflection about the very situation. Because viewers are reflected in their activity, they have to wonder what they themselves are doing at that moment." And so, as is often true in contemporary culture, art's pursuers become the artist's prey.

Thomas Struth. *Pantheon, Rome*. 1990. Chromogenic color print, 54⅛ x 76⅜" (137.5 x 194 cm) sight, 73⅞ x 95¼" (187.6 x 241.9 cm) framed. Fractional gift of Werner and Elaine Dannheisser

Thomas Struth. *Avenue du Devin du Village, Genf*
(Avenue du Devin du Village, Geneva). 1989.
Gelatin-silver print, 16⅞ x 22¾" (42.8 x 57.8 cm) sight,
26½ x 33½ x ¾" (67.3 x 85.1 x 1.9 cm) framed. Gift of
Werner and Elaine Dannheisser

Thomas Struth. *Continentale Gummiwerke, Hannover*
(Continental tire factory, Hannover). 1984. Gelatin-
silver print, 14¾ x 21⅛" (37.5 x 53.6 cm) sight, 26½ x
33½" (67.3 x 85.1 cm) framed. Gift of Werner and
Elaine Dannheisser

Michelle **Stuart**

American, born 1938

"It isn't to prove anything that one collects and/or re-collects from [a] place. It is to commit to memory. Memory is a beginning, a form of natural history: history not of what transpired culturally, but of what might transform naturally." The separation that Michelle Stuart makes here between natural and cultural phenomena came under stern assault in the 1980s: "Nature," postmodernists pointed out, was a human invention, an artificially defined and reinforced category to which people assigned various aspects of reality and varying kinds and degrees of significance. To the extent that "nature" was seen to exemplify or reflect ideas or emotions (a transposition, especially common in Romantic art and literature, that John Ruskin labeled the "pathetic fallacy"), then it could be interpreted as a "text" inscribed by human desire or fear, fantasy or necessity. Those parts of the given environment that humankind did not cultivate by hand, it cultivated with the mind. Under these circumstances the distinction between "nature" and "culture" collapses, with every dimension of the former being absorbed into or permeated by the latter.

Stuart's insistence on the distinction between nature and culture marks her as an artist of an earlier generation — roughly that of Richard Long (see p. 82) and the other practitioners of Earth art in the late 1960s and the 1970s. To note this is not, however, to cede the point that postmodern artists of the 1980s and '90s are more correct in their assessment of this theoretical problem. Indeed, looking at Stuart's work again in the aftermath of postmodernism's heyday is of considerable interest. For no sooner had the notion that everything was a text triumphed than that certainty began to crumble in the face of AIDS and other threats to survival. And then, in a radical swing to the opposite extreme, art started to concern itself almost exclusively with the perishable "body."

Stuart's primary subject lies outside these polarized terms. The "natural" processes that most interest her rarely involve human intervention other than in our capacity as chroniclers of its gradual, primordial transformations. The exception is her research into and reiteration of the mark-making systems with which ancient populations literally incised the previously untouched planet with vast symbols. As a young woman, Stuart spent time working for the Army Corps of Engineers mapping territories from Las Vegas to Korea, and her fascination with these prehistoric pictographs combines scientific expertise with semiotic sympathy, just as her work in general combines the cartographer's grid with the exploratory gesture and sensuous surfacing of the intuitive draftsman.

For the rest, Stuart's preoccupation is with Earth's seasonal cycles and geological composition. These she documents in rubbings that she makes by pulverizing minerals and grinding them into paper — often with stones — until the applied pigments are virtually at one with the support. She began these drawings around 1972, subsequently incorporating into them photographs she made of the places she visited and by this procedure "collect[ed] and/or re-collect[ed]."

Islas Encantadas Series: Materia Prima I (1981) is of this latter type. There is to be sure an element of exoticism in Stuart's choice of locale — in addition to studying astronomical and navigational charts, she travels far afield in search of inspiration — and that exoticism is owed not least to literary associations. The *Islas Encantadas* — the Spanish phrase means "Enchanted Isles," which are more commonly known in English as the Galápagos Islands — were the settings for several of Herman Melville's tales of the sea. Stuart's avowed interest in the Argentine writer Jorge Luis Borges and the Romanian scholar and theoretician of mythology Mircea Eliade further expand the intellectual as well as cultural horizons of her work, with its allusions to temporal relativity, fanciful geographic systems, and ancient cosmologies.

Still, the drawing itself, the series to which it belongs, and the larger body of work out of which it grows remain forthrightly materialistic and free of poetic mystifications. Minimalism rather than Romanticism provides the foundation of Stuart's approach, and while subjectivity informs her facture, a strict conceptual objectivity is at the beginning of her activity and a physical objectivity is its end. Stuart's drawings are certainly cultural artifacts, but their purpose is to draw attention to conditions in the natural world that lie for the most part outside the scope of contemporary art. They are, indeed, a means of committing to memory things she has seen with her own eyes, while creating in the memory of gallery-goers things most of them have never seen at all. In this way Stuart reverses the postmodernist formula, inscribing nature over the text-littered imagination of the cultured.

Michelle Stuart. *Islas Encantadas Series: Materia Prima I.*
1981. Earth from site (Galápagos Islands), graphite,
black and white photographs, and rag paper,
32 x 39⅞" (81.3 x 101.3 cm). Gift of Werner and
Elaine Dannheisser

Lawrence **Weiner**

American, born 1942

Several years ago, in a done-for-laughs segment on the television news magazine *60 Minutes*, CBS correspondent Morley Safer went on at length about all the forms of contemporary art he found ridiculous or contemptible. Among the things he subjected to his smug attentions was the sculpture of Jeff Koons (see p. 76), whom he interviewed on camera and could not get the better of despite all the traps he laid, and Robert Ryman, whose painting of 1988 in this collection — *Convert* (see p. 117) — baffled him utterly. Also on Safer's list of preposterous new aesthetic genres were those that consisted largely if not entirely of words. In a later interview, Jenny Holzer (see p. 139) bore the brunt of Safer's attacks, but it was the whole range of language-based conceptual work that bothered him. Meanwhile, to prove his good intentions and good taste, Safer argued that modernism was all very well with him — he liked Miró, for example — but modernism's most recent manifestations had gone too far when it came to canvases of one color only, such as Ryman's, or works that were nothing but texts, such as Holzer's.

It is common these days for those who are suspicious of the new to belittle it in relation to the now-agreed-upon masterpieces of the formerly new, that is, to attack late modernism with the weapon of early modernism's success. Under these circumstances, love of Picasso, Matisse, or Miró becomes a conservative force, appearing to defend these artists yet violating the spirit in which their innovations were made and foreclosing on future development of their ideas. The irony in Safer's choice of an artist from the past to compare invidiously to those of the present is that Miró happens to have made some virtually monochrome paintings, as well as pictures out of words. Indeed it is possible to trace a history of the use of language in art that covers virtually the whole trajectory of modernism, and includes many of its principal protagonists and a great many more of its minor ones. The issue, then, is not the novelty much less the absurdity of artists employing text as their primary medium, but their changing emphases, linguistic modes, and techniques of presentation.

If Cubist collage and all that immediately ensued from it are selected as starting points, and if Holzer or Christopher Wool (see p. 136) is taken to represent the rising generation of textual artists, then the work of Lawrence Weiner falls some-

where a little past the middle of the historical arc just described. Weiner's first word pieces date from the early 1960s, and still breath the optimism of that moment, when it suddenly seemed to artists impatiently working in a variety of traditional mediums that everything around them offered itself as a material for art — that making images no longer depended on studio craft or automatically "aesthetic" formats. As Weiner and contemporaries of his such as Robert Barry, Joseph Kosuth, Mel Bochner, Sol LeWitt, and Bruce Nauman saw it, artistic quality resided in a valid idea for art expressed in the most efficient means available.

Among Weiner's early works is this conceptual *ars poetica*:

With relation to the various manners of use:
1. The artist may construct the piece
2. The piece may be fabricated
3. The piece need not be built
Each being equal and consistent with the intent of the artist the decision as to condition rests with the receiver upon the occasion of receivership

So saying, Weiner transposed the basic dynamic of verbal language — the communication of an idea from one person to another — into the language of objectmaking, but left it up to the audience for art, "the receiver," how, if at all, that communication would take place. Shifting art's burden away from authorship to exchange, or use, in this way, Weiner opened paths of understanding that relied as much upon the needs of the reader as upon the intentions of the writer.

Not that the ambiguities in Weiner's often fragmentary phrases and syllogistic word equations are strictly philosophical or poetical in nature. The extreme succinctness and strange punctuation and spacing in his texts bring the mind to bear on very specific images or logical puzzles while leaving room for individuals to tackle those referents from several angles at once, thereby elaborating their own significance as active "receivers" rather than containing it as passive interpreters of the artist's original meaning. "My prose is disjointed because I see in terms of nouns," Weiner has explained, "and I see any activity as a noun because I see it as a material process that I understand as art. So that makes me not a very good prose writer. Poetry is

about those untranslatable, unnamable reactions and emotions between human beings to human beings and recollections [*sic*]. The work I do is designed for translation. It is the exact opposite of what poetry is."

Ubiquitous presences in exhibitions around the world — Weiner publishes his work in books and posters, letters it on walls, and disseminates it in various other fashions too — the artist's texts are frequently translated into foreign tongues. By avoiding the exigencies of consistent literary style, Weiner frees himself to write in a variety of ways, depending upon his subject and the occasion. Despite his denials, the effect is often poetic, as though he were trying to fuse traditional Japanese haiku with the stripped-down idiom of linguistic analysis and logical proof. Other times a string of nouns chain-linked by a few articles and prepositions results in word pictures of stunning clarity. *Rocks upon the Beach / Sand upon the Rocks* (1988) is such a work. The vivid description of what is after all a generic scene, this simple phrase contains a more or less explicit conflation of terms — the rocks upon the beach are covered with the sand of which the beach is made by the slow grinding down of the rocks. This verbal landscape may not be to the taste of the Morley Safers of the world (though they tend to like representational art, which Weiner's text most certainly is), but it has all the ingredients of a thought-provoking image in any other medium. And all it requires, like any other work of art, is imaginative engagement on the "receiver's" end.

Christopher **Wool**

American, born 1955

Often Christopher's Wool's paintings sound an alarm: "RUN," reads one, while another says "RIOT." Sometimes they speak in riddles — "CATS IN BAG BAGS IN RIVER" — or ask cryptic questions: "WHY MUST I FEEL THAT WHY MUST I CHASE THAT CAT." And occasionally they tell jokes, like "THE SHOW IS OVER THE AUDIENCE GET UP TO LEAVE THEIR SEATS TIME TO COLLECT THEIR COATS AND GO HOME THEY TURN AROUND NO MORE COATS AND NO MORE HOME." The fact that the story really isn't that funny is of no apparent concern to its unidentified author, who, if we interpret the texts of related paintings as possible self-portraits, is a self-acknowledged "CHAMELEON," "PRANKSTER," or rhetorical "TERRORIST." Whatever he may be, it is plain that he has little regard for public piety or sensitive nerves. "FUCK EM IF THEY CAN'T TAKE A JOKE," declares a recent drawing.

Whatever Wool's paintings have on their mind they shout out in oversized block letters. But as they shout they also tend to stammer, so that letters are separated from the bodies of the words, or words run together, creating hard-to-decipher compounds. Thus the actual typography of the short narrative above goes as follows, with slashes indicating line breaks:

> THESHOW ISO / VER THEAUD / IENCEGET UP /
> TOLEAVE THE / IRSEATS TI / METOCOLLECT /
> THEIR COATS / AND GOHOME / THEYTURNARO /
> UND NOMORE / COATS ANDNO / MOREHOME

The world according to Wool is a place on the edge of disintegration, just as his sentences and sentence fragments are examples of no-nonsense words on the verge of turning into totally nonsensical syllables. How much we depend on language to order experience is obvious from such exercises in deliberately disordering spelling, syntax, and implied utterance.

The linguistic gamesmanship Wool engages in has a long and complicated history. Its antecedents include the Dadaist practice of cutting texts up, letting the pieces fall onto a piece of paper, and then gluing them into place to create new texts. Such anticompositional techniques of the teens and '20s were further developed by the Lettrists of the '50s and '60s, who reduced the basic structures of language to a rubble of isolated sounds, and, performing them aloud,

turned Dada's babble into ear-grating squawks. More recently there have been the contributions of conceptual grammarians such as Lawrence Weiner (see p. 134) and Joseph Kosuth, and the haunting wordplays of Bruce Nauman, with which Wool's paintings share a marked verbal and emotional affinity (see p. 92).

A feeling of impending doom pervades Wool's work. Trouble may in fact be not far off at all, but right here, as the title of one piece in this collection, *Apocalypse Now* (1988), explicitly states. The phrase directly cites the movie of the same name — Francis Ford Coppola's retelling of Joseph Conrad's *Heart of Darkness* as an episode in America's disastrous adventure in Vietnam — and the words Wool has appropriated for the painting are those of the film's protagonist, a trained military assassin who goes AWOL during a mission to kill a maverick American colonel and leaves behind a note saying "sell the house / sell the car / sell the kids / find someone else / i'm never coming ~~home~~ back / forget it." This parting message is a succinct statement of the American dream of security gone sour, and of the American faith in freedom gone crazy and on the run. Its basic assumption reiterates the conclusion of the untitled 1991 drawing previously mentioned, which begins "THE SHOW IS OVER" and ends "NO MORE HOME."

Wool grew up in the 1960s, and the disillusionment implicit in these texts came all too naturally to him. It extends to America in its business-as-usual mode. The words CATS IN BAG BAGS IN RIVER in *Untitled* (1990), a work in the collection of The Museum of Modern Art, come from *The Sweet Smell of Success*, a 1957 melodrama about the creation and destruction of public images. They are spoken by a press agent and all-around fixer, who boasts of having disposed of a problem in these terms. Pulling the lines out of context in this way, Wool adds resonance to them, but that displacement — emphasized by the white grounds underlying his painting's shiny black letters — only serves to amplify the shallowness or hollowness of the phrases, as does his fairly frequent use of repetition, for example SELL . . . SELL . . . SELL. In Wool's work we hear the echo of popular culture and of common parlance, but most of all we hear a bleak generational assessment of the status quo. The sentiments voiced are not nihilistic, but rather those of a jumpy contemporary realism.

Christopher Wool. *Apocalypse Now*. 1988. Alkyd and Flashe on aluminum and steel, 84 x 72" (213.4 x 182.9 cm). Loan to The Museum of Modern Art, New York, from Elaine Dannheisser

Supplement

The two works below are multiples that were produced by the Dia Center for the Arts, New York, in connection with one-person exhibitions by each of these artists.

Francesco Clemente. *Funerary Painting*. 1988.
New York: Dia Center for the Arts. Artist's book.
Page: 12 ⁵⁄₁₆ x 28 ¹¹⁄₁₆" (31.3 x 72.9 cm). Edition: 1000.
Gift of Werner and Elaine Dannheisser

IS ARITHMETIC.
I COUNT INFANTS AND
PREDICT THEIR DAYS.
I SUBTRACT PEOPLE
KILLED FOR ONE
REASON OR ANOTHER.
I GUESS THE NEW
REASONS AND PROJECT
THEIR EFFICACY.
I DECORATE MY
NUMBERS AND
CIRCULATE THEM.

Jenny Holzer. *Laments*. 1989. New York: Dia Center for the Arts. ½-inch videotape and book, book 7¾ x 4½ x ⅛" (19.7 x 11.4 x 0.3 cm). Gift of Werner and Elaine Dannheisser

Photograph Credits

Individual works of art appearing herein may be protected by copyright in the United States of America or elsewhere, and may thus not be reproduced in any form without the permission of the copyright owners. The following and/or other photograph credits appear at the request of the artist or the artist's representatives and/or the owners of individual works. The following list applies to photographs for which a separate acknowledgment is due, and is keyed to page numbers.

Leo Castelli Gallery, New York: 23, 97, 103.

Barbara Gladstone Gallery, New York: 25, 112.

Robert Gober Studio, New York: 49, 52, 57.

Marian Goodman Gallery, New York: 135.

© The Solomon R. Guggenheim Foundation, New York. Photograph by Mary Donlon: 17.

© Jeff Koons: 80, 81. Photographs by Douglas M. Parker: 78, 79.

Luhring Augustine Gallery, New York: 71.

© Estate of Robert Mapplethorpe. Used by permission. Rephotographed by Kate Keller: 10, 144.

Matthew Marks Gallery, New York: 88, 89. Photograph by Thomas Rutt, Düsseldorf: 45.

© The Museum of Modern Art, New York. Photographs by Kate Keller: 31, 34, 35, 37, 67, 69 (both photographs), 73 (both photographs), 85, 102, 105, 107, 108, 109, 113, 115, 117, 129, 131, 137, 138. Photographs by Erik Landsberg: 13, 15, 16, 39, 75, 99, 110.

© 1997 The Museum of Modern Art, New York. Photographs by David Allison: 21, 27, 32, 40, 41, 53, 54, 55, 56, 77, 83, 91, 93, 95, 98, 100, 111, 119, 121, 139.

© 1997 The Museum of Modern Art, New York. Photographs by Bill Orcutt: 20, 26, 29, 43, 50, 51, 62, 96, 120, 130, 133.

Plane Image, New York: 87.

Andrea Rosen Gallery, New York: 59, 61, 64, 65.

Cindy Sherman and Metro Pictures, New York: 123. 125, 126, 127.

Sonnabend Gallery, New York: 47.

Sperone Westwater, New York: 101.

Elaine Dannheisser.
Photograph: Robert Mapplethorpe, 1987